PHOTO IMPRESSIONISM

AND THE SUBJECTIVE IMAGE

Books by Freeman Patterson
Photography for the Joy of It
Photography and the Art of Seeing
Photography of Natural Things
Photographing the World Around You
Namaqualand: Garden of the Gods
Portraits of Earth
The Last Wilderness: Images of the Canadian Wild
Shadowlight: A Photographer's Life
Odyssey: Meditations and Thoughts for a Life's Journey

Books with photography by Freeman Patterson
In a Canadian Garden by Nicole Eaton and
 Hilary Weston

Books with photography by André Gallant
Winter by Pierre Berton
The Great Lakes by Pierre Berton
Seacoasts by Pierre Berton

PHOTO IMPRESSIONISM

AND THE SUBJECTIVE IMAGE

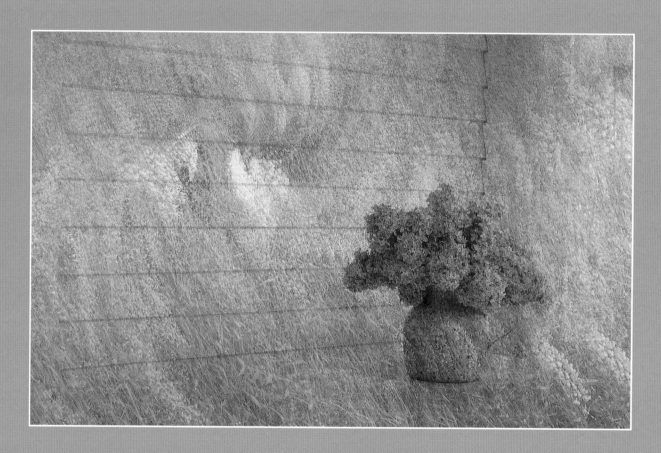

Freeman Patterson and André Gallant

KEY PORTER BOOKS

National Library of Canada Cataloguing in Publication
Data

Patterson, Freeman
 Photo impressionism and the subjective image

ISBN 1-55263-327-6

1. Photography, Artistic. 2. Impressionism (Art). I. Title.

TR642.P38 2001 778.8 C2001-900609-8

The publisher gratefully acknowledges the support of
the Canada Council for the Arts and the Ontario Arts
Council for its publishing program.

We acknowledge the financial support of the Govern-
ment of Canada through the Book Publishing Industry
Development Program (BPIDP) for our publishing
activities.

Key Porter Books Limited
70 The Esplanade
Toronto, Ontario
Canada M5E 1R2

www.keyporter.com

Editor: Clare McKeon
Design: Counterpunch/Peter Ross
Color separations: Quadratone Graphics Ltd./
 Tom Childs

Printed and bound in Canada

01 02 03 04 05 06 6 5 4 3 2 1

For Colla, Joanne, Kim, Olga, Parker, and Susan

Acknowledgments

We warmly acknowledge the creative stimulation of hundreds and hundreds of our workshop participants who have unconsciously contributed to the making of this book. Thank you, all.

Contents

Preface

Freeman: This is the fifth in the series of instructional books on photography and visual design that I began in 1977, but it is the first to be co-authored with André Gallant. In 1996 André became my teaching partner and co-director of the New Brunswick workshops that I founded twenty-one years earlier. Having André as a friend and partner is a richly rewarding experience. We stimulate each other creatively, and grow visually and personally as a result. André is, quite simply, a joy to work with, and our workshop participants appreciate his "laid-back" demeanor, coupled with his strong sense of responsibility and unusual sense and love of color.

André: As an avid amateur photographer in the early 1980s, I was greatly inspired by Freeman and his books *Photography for the joy of it* and *Photography and the art of seeing*. I was fortunate to attend one of his seminars, and from that day on, photography ceased to be a hobby and evolved into a creative force in my life. Becoming a professional photographer was long and arduous, but certainly worth every struggle.

A few chance meetings with Freeman led to a biking outing (we both owned Harley-Davidsons at the time) on an August weekend in 1993. A friendship ensued, and a teaching partnership began three years later. The photo workshops we conduct in New Brunswick every year are, for us both, satisfying life experiences. The learning, the sharing, and the friendships we make go far beyond photography.

Freeman and André: This book is about the creative use of your camera and various photographic techniques to help you translate your feelings and emotions onto film. We are writing and illustrating it together because we believe that both the similarities and the differences in our work will be helpful to other photographers and to people who study photographs as an artistic resource. Slide montages allow André to create "dream-like" images that have a kind of timelessness, often evoking a romantic mood, while multiple exposures enable Freeman to go beyond a literal rendition of subject matter to the truths of emotions. We hope that these and other expressive techniques will enable you to move to new ground of your own. Similarly, the presence or juxtaposition of the colors that trigger our emotional responses may lead you to explore other combinations and renditions of your own.

Above all, we hope our discussions and suggestions will encourage you to experiment visually. Your photography should be a form of self-expression for you and others to enjoy.

Shamper's Bluff and Saint John,
New Brunswick, Canada
April 2001

PHOTO IMPRESSIONISM
AN INTRODUCTION

The depiction in photography of emotion or character by details intended to achieve a vividness or effectiveness more by invoking subjective and sensory impressions than by re-creating an objective reality.

ADAPTED FROM MERRIAM-WEBSTER'S DICTIONARY

The key to seeing the world's soul, and in the process wakening one's own, is to get over the confusion by which we think that fact is real and imagination an illusion. It is the other way around.

THOMAS MOORE, "ORIGINAL SELF"

The great tradition of still photography is documentation, the representation of objective reality. The photographer observes a scene, a situation, or an object and responds to it by endeavoring to show it as it appears. The average person on vacation, a parent who is photographing the family, and probably a large majority of serious amateurs and professionals operate mainly within this tradition. There is, however, a second tradition, that of altering physical reality for the purpose of expressing the photographer's personal response to specific subject matter or to a concept or idea.

Many photographers work within both traditions and may produce deeply expressive realistic images as well as non-literal or non-realistic ones. Certainly the realistic visual documents of Margaret Bourke-White revealed the human condition in a way that stirred viewers deeply; Ansel Adams "intensified" the physical realities of nature, primarily through his printing, to make them appear even more real; and the nature images of Frans Lanting both rivet our attention and stimulate a strong emotional response. However, the "impressionist" photographer deliberately abandons physical exactitude in the belief that, by doing so, he or she can convey more effectively the reality of feeling.

Nobody is an impressionist all the time, but more and more photographers are becoming one part of the time, because they experience a degree of frustration if they confine their efforts to recording what they *see*, when they want to convey what they *feel*. The first section of this book is intended to help photographers venture into some aspects of the non-literal world of photography and create (or, for that matter, record) impressions that convey a truth of feeling or spirit.

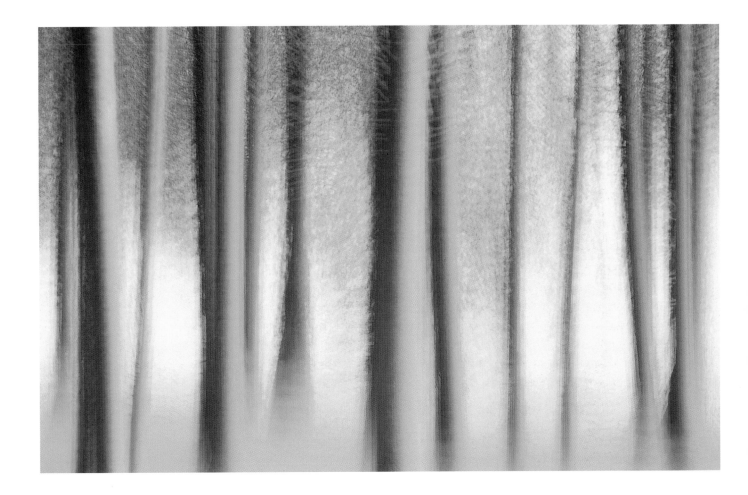

At first glance it's difficult to tell if this is a multiple-exposure image or a single, vertically blurred one, because the trees have almost no horizontal branches that cut across the dark vertical trunks. However, a careful inspection will show you which it is. For me, either approach would produce a more ghostly appearance than a literal picture in which details are clearly defined. Here everything is "in focus," but in moving the camera upward vertically through sixteen exposures, I made sure that no two exposures were in register but that all were still "in line."

Multiple exposures

One December morning about five or six years ago I had an experience that made me aware of a new direction in my photography, a direction in which I had been moving, almost without my realizing it, for several years. As I opened a door onto my deck, I was struck by the integrated pattern of beaten-down brown grasses, their tiny black shadows, and a scattering of snow in the field behind my house. I ran for my camera and tripod, and for nearly an hour made images of the field, images that contained no dominant lines or shapes, nothing whatever that would pass as a center of interest. Then, feeling euphoric, I made a cup of tea, sat down on the deck, and asked myself why I was so excited. After a few moments I realized that, in abandoning the use of shapes and lines, I had focused entirely on texture, the weave or fabric-like nature of surfaces.

More important, I realized that this change mirrored my life. When I was younger I had goals in mind (shapes), and visualized roads or pathways leading to them (lines). But as I grew older I accumulated a wealth of memorable personal experiences and significant relationships, and my life became less the pursuit of a goal than the appreciation of a richly woven tapestry. The threads of all these experiences and relationships were like a texture, and my photography made me consciously aware that the field functioned as a visual symbol for my life.

A few days later, sorting through transparencies made in previous years, I was able to discern where this change had begun. Just a single image at first, then a few more, and then more yet. I was looking at an unconscious tracing of my personal history. What had happened to me was identical to what has happened to other photographers and to artists working in other media. The adage that your art precedes your understanding of it by at least a couple of years seemed very apt in my case. But the fact that I was now *aware* of what I was doing made me seek out and explore a variety of textures.

Then one day I thought, "I'm looking for existing textures, but surely I can create textures too." To achieve this, I commenced, among other things, making

multiple-exposure photographs – usually nine or sixteen images on one frame of film. It's an old technique that suited my intention perfectly. Although I found good examples of multiple exposures made by other photographers, I could not find a large body of work by any one person. So, using trial and error and dozens of rolls of film, I set out to master a variety of approaches. My mistakes, failures, and not very good pictures taught me as much as my successes, and before long I began to fall in love with many of the effects that I was able to achieve.

There are two basic types of multiple exposure:

1 / Repeated exposures of the same subject matter, with each exposure slightly out of register with all the others. This type tends to produce a highly impressionistic effect.

2 / Repeated exposures that combine different subject matter. This type often results in an image that is highly non-representational or abstract. Since the subject matter varies from one exposure to the next, or from several exposures to several more, registration is rarely a consideration.

We'll consider each type separately, but first let's examine the important matter of how to expose them appropriately, or effectively. I've never believed that there is only one "correct" exposure for any sort of photograph.

If you have a camera that allows you to make multiple exposures on a single frame of film, you can achieve effective exposure in either of two ways. Let's assume that the film in your camera has a film speed of ISO 100.

1 / You can re-rate the film speed, increasing it by the number of images you want to make. For example, if you want to make eight or nine images on a single frame, you will change the film speed setting on the camera to 800. (Since there will be no 900 setting on your camera, for nine exposures you should also set the camera at 800. This will have a minimal effect on the result.)

2 / Or, you can take the square root of nine, which is three, and use the function button to dial "minus three," underexposing the same amount as when you increase the film speed. This is the easier method with my cameras, and consequently the one I use. For sixteen images on a single frame I dial "minus four," but I sometimes make two or three extra images if I think reciprocity failure – the tendency of films to underexpose a little at very long or very fast shutter speeds – may be a problem.

Usually, a film with a low ISO rating or slow speed is fine for shooting multiple-exposure images, because each individual exposure is shot at a relatively fast shutter speed. For instance, if you were shooting a single-exposure image at $\frac{1}{60}$ second, you'd be shooting at about $\frac{1}{500}$ second for each of the nine exposures if the light intensity were the same. Some cameras limit the number of exposures possible on a single frame (often to nine), but you may find you can shoot eight of the nine images you want and then reset the camera for an additional nine, making seventeen images possible, or reset it again for twenty-five, and so on.

Now let's consider the first type of multiple exposure, where the subject matter remains the same from

one exposure to the next. There are several possible approaches, but each of them depends on your composing carefully before you begin or, if you plan to move the camera somewhat during the exposures, carefully checking what will be in your entire field of view.

1 / You can simply point a hand-held camera at the subject matter and make, say, nine exposures. Since nobody can hold a camera in exactly the same position for successive exposures, each one will be minutely out of register with all the others. The resulting image is usually very textured, often painterly (see page 19). If you deliberately move or shake just a little, the effect will be slightly different (perhaps like the picture on page 17), so try that as well. In this and other approaches it's wise to make four or five multiple-exposure photographs and then choose the one or two that appeal to you the most.

2 / You may want to try moving the camera up or down, or left to right or right to left, or obliquely, while repeatedly pressing the shutter release. (See the picture of a biker on page 20.) This approach is often most effective when a line or series of lines is part of your original composition and you take account of the orientation and direction of these lines (page 11). You may be tempted to move or swing the camera too much – a little is often entirely sufficient – so let the subject matter guide you. If you reach the far point of your swing or movement before you finish making all the exposures, reverse direction. (For an explanation of panning and blurring, similar movement techniques used in single-exposure images, read pages 61-62. See the chapter "Familiar techniques.")

3 / You can rotate your camera slightly (or more than slightly) around a fixed point anywhere in your viewfinder (see page 21). Usually, very little rotation will achieve quite a dramatic effect, because all parts of the picture space are rotating except the fixed point. The sense of rotation increases as the distance from the fixed point increases. Also, you can rotate your camera for some but not all of the exposures – let's say for three or four exposures out of a total of nine. You can see this approach in the picture on page 24, for which I made four exposures of the yellow daisies without moving the camera and then five more while rotating it a little.

4 / For a very dramatic effect you can zoom a lens on any fixed point within the picture space. If you choose a fixed point that is not the center of the picture (and this is a perfectly reasonable thing for you to do, even though every single-image zoom automatically has the center of the picture as the fixed point), you have to adjust the camera's position after each exposure to make sure the fixed point remains in exactly the same spot in the viewfinder. This is much easier to do when you have your camera on a tripod. (See page 22 for an illustration.) Also, I suggest that you always zoom from a shorter focal length to a longer one (perhaps 88mm to 93mm to 101mm to 109mm, etc.) to make sure that the area you're covering is getting smaller, not larger. This way nothing unexpected will creep into your final image at any of the edges.

5 / For a very powerful spiral effect you can rotate and zoom the lens at the same time on any fixed point (see page 23). This is also much easier to do when your camera is on a tripod, because you will have to zoom a

few millimeters, say from 136mm to 144mm, and also rotate the lens slightly after each exposure, which means you will need to adjust the camera's position to keep the fixed point in your composition at a fixed point in the viewfinder as well. With this approach I find that a longer series of exposures (sixteen, for example, rather than nine) gives a stronger effect.

With all of these approaches it's a good idea to pre-compose your multi-exposure image. Do a "run-through." If you are planning to rotate your camera during sixteen exposures, tilt the camera to the left, then rotate it up to level, and then tilt it as far down on the right as you plan to go. In the test you may find, for example, that at the level position you are inadvertently cutting off the tops of trees. Then run through a second trial or more, until you determine just how you want to proceed, perhaps with the camera aimed higher or lower and/or rotating not so far from the left to the right.

How quickly should you make the repeated exposures? There is no easy or simple answer to that. Normally, you can and will do it quickly, in a matter of a few seconds. But if you want to set your camera up on a tripod and make an exposure every half-hour for eight hours, go ahead. If you have an extra tripod and a spare camera and a compelling urge to do something of an extreme nature, make a single exposure of a chosen scene once every month for twelve months. You can rotate or zoom or slightly reposition the camera before or after each exposure, but be sure to save the battery by turning the camera off after each exposure. I've never seen the result of such an attempt, nor do I know anybody who has tried it. So, if you try, your photograph might be a candidate for the *Guinness Book of Records*!

In the second type of multiple-exposure image you will combine exposures of different subject matter. The subject matter can differ a little or a lot. For example, in four exposures on one frame you may want to combine the leaves of a tree, a field of daisies, some clouds, and a person. For eight exposures you might combine two shots of the leaves (one closer, one more distant), two exposures of the flowers, three of the clouds (each slightly different perhaps), and one of the person. Sometimes I will shoot four images of one part of my garden, each slightly out of register, and then four more of another part of the garden, each somewhat out of register with the others or rotated. (See page 25 for a garden image.)

Remember that you can always have some of the exposures in focus and others out of focus. However, in many cases out-of-focus material can be detrimental to the composition. You should experiment, because it's the only way to discover what appeals to you and what doesn't. And watch out for shutter speed. If you are hand-holding your camera at a slow speed, you will combine a lack of sharpness in each image with the out-of-register effect. Generally, these effects do not combine well. There are exceptions, but they are rare in my view, so when I'm hand-holding, it's usually at a shutter speed of at least $\frac{1}{90}$ second, or faster with a lens of 100mm or longer.

Any technique has value to the extent that it helps you accomplish what you feel. This is certainly true of multiple exposures. For me, they help to create the visual sense of texture and stimulate the feelings that differing textures can evoke. Yet my exploration of this old technique also led me to discover something

else — something that will challenge me for years, probably for the rest of my life. It has made me very aware of the visual similarity between multiple-exposure photographs and dreams.

In fact, many dreams are multiple-exposure images, almost all of them of the second type. A cow wanders into your bedroom, knocking over a Christmas tree whose fall smashes a favorite vase. Cow, bedroom, Christmas tree, broken vase: a tall order for a photographer making multiple-exposure images, but not an impossible one. Dreams often seem obscure when you attempt to analyze them but become real and immediate again when you remember or re-experience the feelings they generated. Dreams are often very sensuous. They arouse strong emotions and stimulate intuition. That's also true of many multiple-exposure images. For both dreams and multiple-exposure imagery, it's often better to explore what or how they make you feel than to ask, "What is it?"

In *The Two Million-Year-Old Self* an internationally known Jungian analyst, Anthony Stevens, writes: "Indeed, images must carry precedence over words, for as any analytic session demonstrates, dream images invariably reflect more than the dreamer has previously understood or has ever attempted to express verbally." This is a very positive confirmation of an impressionist's efforts, and it acknowledges the important role that visual symbols play in our lives and in our photography. It is not surprising that the symbolism of the field of brown grass behind my house led me, photographically, beyond that field into another symbolic realm. You should feel encouraged, indeed excited, at the prospect of going for the truths that lie beyond the literal. **FP**

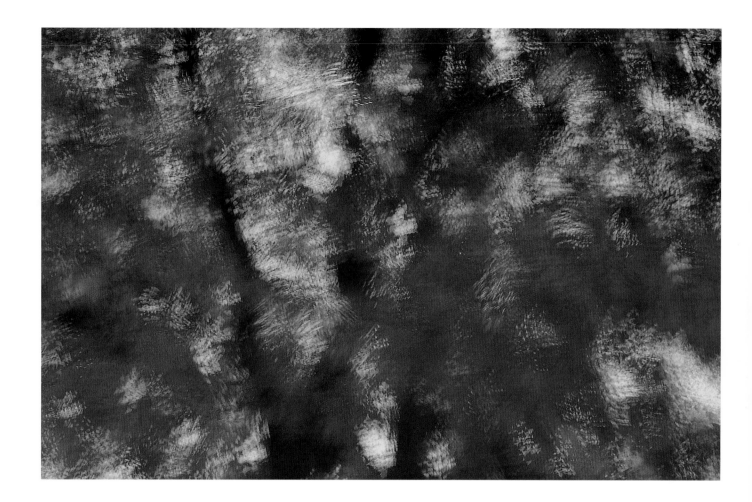

My technique here was exactly the same as for the image on page 19, but I seem to have moved the camera a little more between at least some of the exposures. It's often a good idea to make more than one multiple-exposure image of a composition, altering the amount of movement slightly in each case.

When you compare the results, you'll usually be able to choose your favorite quickly, and after a short time you'll have a good idea of the amount of movement you prefer for various kinds of subject matter.

As I made this multi-exposure image (between nine and sixteen individual exposures), I moved the camera up (or down) on a slight oblique. This gave a gentle dynamic to the flowers – a sense of vibrant, vigorous growth. Before shooting, I checked carefully through the viewfinder to determine how far up and down I could tilt the camera without introducing extraneous material into the image area. Had I used a slow shutter speed (say, $1/4$ second) for a single exposure and moved the camera in the same way during the exposure, I would have produced streaks of color instead.

Every spring I photograph this old apple tree blooming at the edge of the woods not far from my house. After years of doing this, I realized that its appeal for me lies in its dreamlike appearance. So, one year I stood on my deck hand-holding my camera, with a zoom lens set at about 250mm, and made a series of nine exposures, each one more or less on top of the other. Although every image is sharp and in focus, each is slightly out of register with all the others, giving the dreamy impression that I wanted to convey.

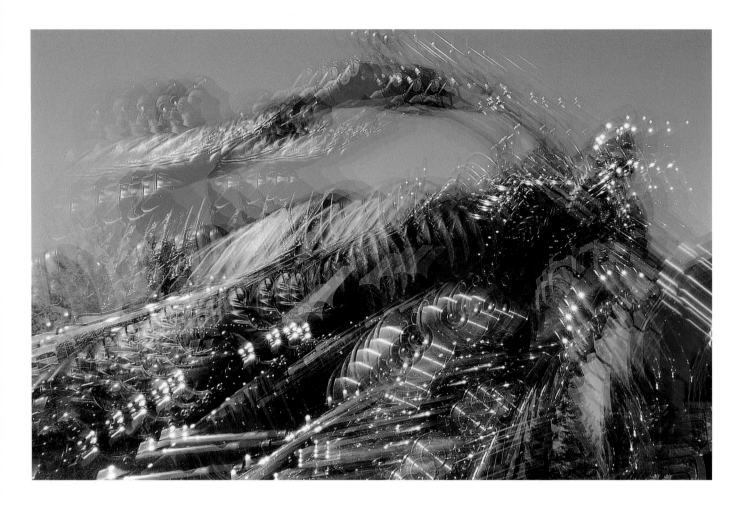

The biker sitting on my Harley was not riding; the sense of movement came entirely from my swinging the camera from right to left and slightly downward. Because I was using a 50mm lens and tilting the camera up from a low position, there is some perspective distortion in the bottom half of the image that gives a greater sense of oblique movement in that part and more dynamic to the image. If you have two or three motorcycles together, you can create an entire bike rally through multiple-exposure techniques.

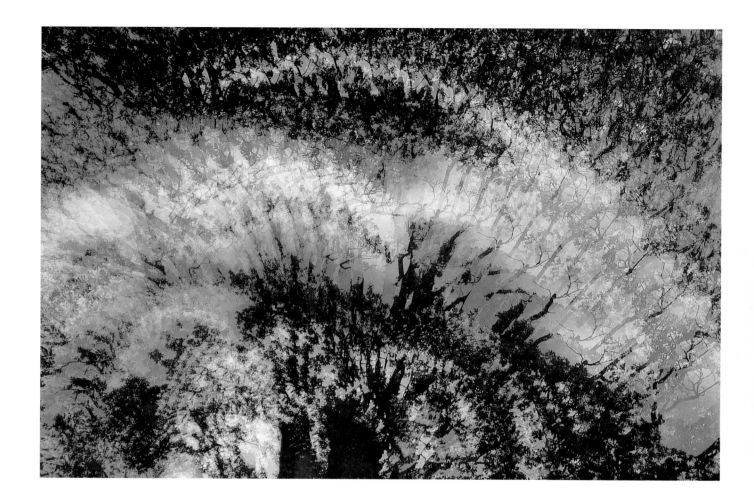

Trees are a metaphor for human life. They bend in the wind, they yield to the force of storms, but when the winds and storms have abated, most of them snap back and stand tall again, because they are rooted in the soil. I used multiple exposures to convey this metaphor, something I could not have done with a single exposure. For this photograph I chose to make the black tree trunks (slightly to the left of center on the bottom edge) a fixed point, and I rotated the camera around that point while repeatedly pressing the shutter release. The parts of the tree that are farthest from the fixed point show the most rotation, or the greatest sense of bending.

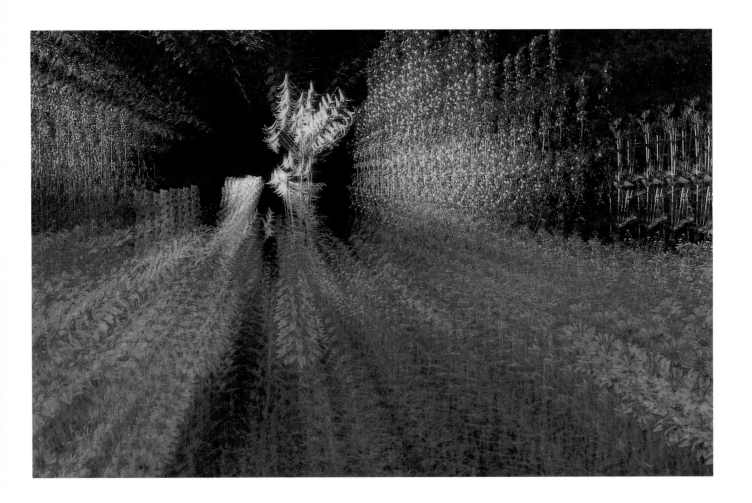

These are the same lilies and other flowers that you can see on page 18, but two things are different. Here I had late evening sunlight and dark shadows instead of the soft, even light from an overcast sky. And rather than swinging or "panning" the camera through several exposures, I "zoomed" the lens after each exposure. For example, if I started at 100mm, the next image was made at about 106mm, the third at 113mm, and so on for about sixteen exposures on the same piece of film. After each individual exposure I repositioned the camera slightly on the tripod to keep the orange lilies in a more or less fixed position.

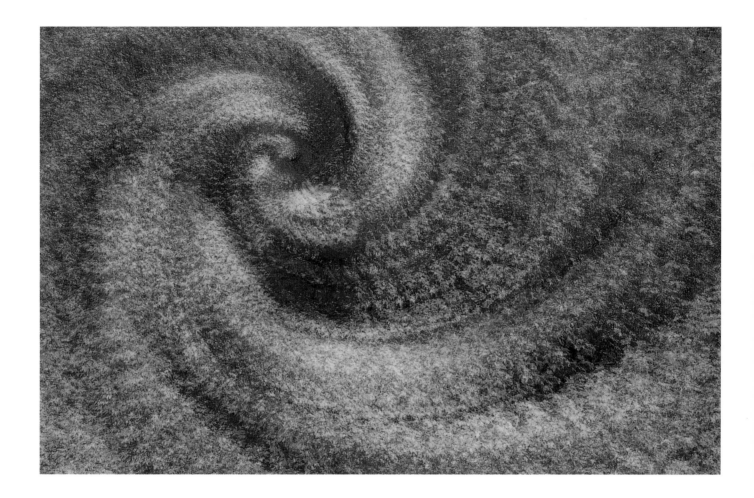

For me, the vibrant yellow of a maple tree and the contrasting spot of blue sky seemed to demand powerful treatment. I created a strong spiral effect by rotating the camera and zooming the lens during a large number of exposures (between sixteen and twenty-five exposures in this case, but nine is about the minimum). When you try this, reposition the camera slightly after each exposure so that some point in the picture space remains fixed. Use a tripod at least the first few times you try – maybe always – as it's more difficult to be reasonably exact when you are hand-holding your camera, although it's not impossible.

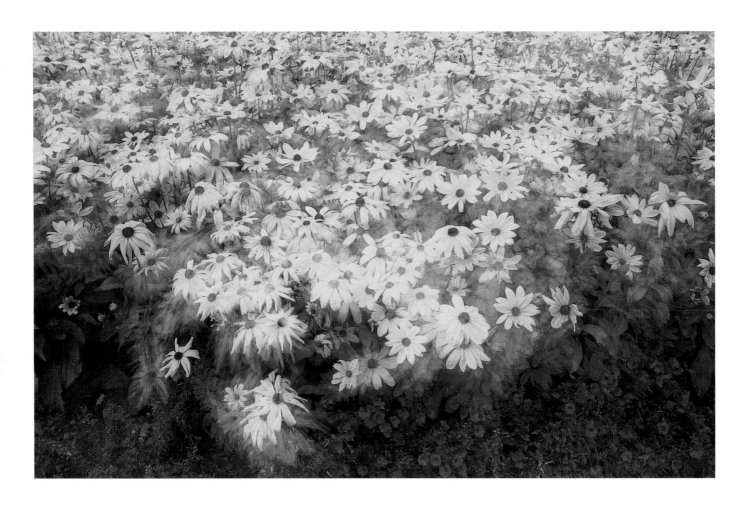

The aura of movement, the sense of flowers tossing in a breeze, is something we often see and feel but may have difficulty expressing visually. Here I made it visible by creating a visual "equivalent" to movement. Placing my camera on a tripod, I made four exposures without moving the camera, then I loosened the tripod head and continuously rotated the camera slightly while making five more exposures.

24

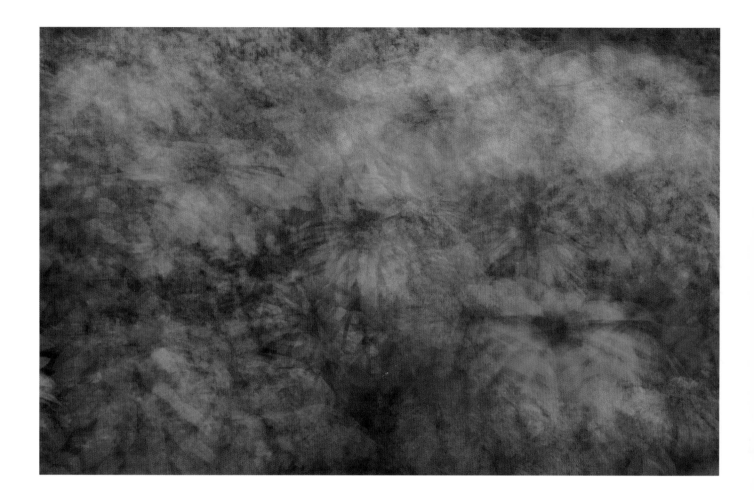

This colorful tapestry of flowers existed not in my garden but in my imagination. After surveying the masses of yellows, oranges, blues, reds, and other hues, I decided to focus on several yellow daisies and made four or five exposures, hand-holding the camera. Then I moved to another part of the garden, chose some large mauve blossoms of phlox, threw them out of focus, and added four or five more exposures without advancing the film. Perhaps I should add that this is only one of many tapestries I created that morning.

Slide montages

A few summers ago, as I was editing film, I dropped two slides on my light table, one on top of the other. The images were of the same subject but photographed from different perspectives. I was immediately intrigued by the combination and felt an urgent need to explore further the familiar technique of slide sandwiching. I started combining different images, often overexposing my film so I could overlap two images and get a well-exposed montage. I also repeatedly created montages of the same scene, with one image in focus and the second out of focus, overexposing both pieces of film to obtain a proper exposure for the final, combined image. I've now become addicted to this type of montage.

Recently, I spent a day making photographs in an old car lot. I decided to do the entire shoot as montages. The effects amazed me. These were decrepit old cars, their metallic paint corroding and disintegrating. Rusting surfaces came out looking like Mark Rothko canvases. Shattered windshields became mysterious. Worn tires covered in frost gleamed in cool, sullen hues. Colors blended, spilling over each other and glowing through

the use of montage. The technique emphasizes the abstraction of an image.

A slide montage consists of two pieces of film, or occasionally three, placed together in a single mount. It is, quite simply, a slide sandwich. To achieve a successful montage the two or three pieces of film must be overexposed, as you'll be stacking them on top of one another. This technique will enable you, among other things, to turn ordinary scenes into surreal dreamscapes. You can get wonderful results any time, even on dull gray days. I've been making montages extensively for over two years now. What excites me most is that I'm not always certain of the outcome.

The first type of slide montage uses two or three images of the same scene, one in focus and one, or maybe two, out of focus. This type of montage is my favorite, producing images that are often surreal, with a soft ethereal glow. I call them dreamscapes. For this effect, you must use slide film. Attach a telephoto, zoom lens (in the range of 100mm to 300mm) or macro lens to your

camera. The use of these lenses will enable you to produce an out-of-focus image, a blur of colors, which is essential for this type of montage. If you use shorter lenses – 50mm to wide angle – it is difficult to get an out-of-focus image lacking detail, as these lenses afford greater depth of field. Place your camera on a tripod; it's obligatory for this kind of montage.

When you have chosen your scene, take the first picture in focus, with adequate depth of field, but overexpose it by two stops. If you shoot on manual or aperture priority, you can accomplish this by reducing the shutter speed two full stops (for example, from $\frac{1}{125}$ second to $\frac{1}{30}$ second). If you shoot on shutter priority, open up the lens two full stops, from f/22 to f/11. Overexposing by altering shutter speed will not affect the depth of field you have chosen. Some cameras have an exposure compensation button or dial, and you can overexpose by setting this button or by dialing +2.

With your camera still on the tripod, throw the same scene out of focus (blur and enlarge the image and eliminate all detail); use the lens's widest aperture, f/2.8 or f/4, for a lack of depth of field; and overexpose this second image by one full stop.

Use this method as a starting point, but feel free to experiment with different overexposure combinations.

The result should be two bright, overexposed slides for each planned montage. The in-focus image will be the lighter, resembling a skeleton of the scene you photographed. The out-of-focus image will be a soft blur that retains most of the color. Remove both pieces of film from their mounts and then remount them, one on top of the other. It doesn't matter which piece goes on top. At this point the magic appears. Your "montage" will be well exposed and have a dreamy quality to it. You

can buy special slide mounts for montages (Gepe is one manufacturer) that will take up to three pieces of film. I recommend the glassless mounts, because slides easily get damaged when glass mounts break.

During a trip to the Yucatán peninsula in Mexico, I discovered amazing graveyards with colorful ossuaries (repositories for the bones of the dead). I made montages of them using three pieces of film, producing a more impressionistic image. The first photograph, in focus with good depth of field, was overexposed by two and a half stops. Then I threw the image out of focus and opened the lens wide for two shots, overexposing the first frame by one stop and the second frame by one and a half stops. The glowing bones against the dark colors of the ossuaries add impact to the evocative images.

As you experiment with this technique, you will find that varying the amount of overexposure produces different effects. Use the technique described above as a guide, and treat the "overexposure" as you would an ingredient in a recipe; you might want to use a bit more or less. The more you overexpose the in-focus picture (but don't exceed three stops), the more surreal your final image.

What is the difference between a montage and a double exposure? By overlapping two (or three) fresh pieces of film, the montage has greater color saturation, with a more pronounced glowing and ghosting quality. The combined film emulsions reduce contrast in the highlights and alter the colors. A double exposure, on the other hand, exposes the same piece of film twice, thus reducing color saturation compared with the montage.

The second type of slide montage uses two different images to create a unique photo, an unusual third

image. Two slides that are both well exposed and light in tone combine well. For example, a photo of a white or pink flower can be combined with a photo of peeling paint, or perhaps an image of water drops on a glass windowpane, like the image of the white begonia with the water drops on page 36. Because both slides are tonally bright, no alteration is needed in their exposure. However, if you combine images that both have dark subject matter, you may need to choose slides that are overexposed. I often deliberately overexpose certain scenes – stones, grasses, fields of flowers, or the ripples of a disturbed water surface – that I feel may work well in a montage. Textured images are especially effective when combined with other scenes, such as landscapes, nature, or people.

With montages you will be able to make good use of overexposed slides. Keep them in a box or file. Once you've accumulated a wide selection, start combining them. The results will surprise you. This is how Freeman and I came up with the image on the cover of this book. We spent an evening combining images, and we agreed that this montage – a multiple exposure of a field of lupins plus a lilac bouquet on a white table – expressed how we felt about photo impressionism.

The third type of montage uses two identical images, reversed over each other. Both slides should be light in tone or overexposed. Reversing them will create a kaleidoscopic, symmetrical effect. Scenes with lines, patterns, or definite shapes make montages that are visually intriguing and powerful.

I've montaged two bright, identical slides of backlighted ferns, reversing one over the other. The resulting image is of criss-crossing leaves forming an unusual grid. The abstract image on page 35 is a close-up detail of an iris, where both slides were overexposed by one stop, then reversed on top of each other. The use of darker subject matter in a montage will require overexposed slides; otherwise the final image will be too dark. I have created several montages of this type using images of stones. Because the rocks were quite dark (browns and dense greens), I had to overexpose the pictures by one and a half stops in order to obtain a properly exposed montage.

I recommend that you make copies (duplicate slides) of your successful montages. This is especially important if you project your slides. The heat from the projector lamp could induce Newton Rings (unsightly circular patterns that sometimes appear when two pieces of film touch); or if there is moisture between the pieces of film, condensation might cause them to stick together, producing noticeable marks.

When you start exploring montages, you'll soon realize that the possibilities are endless. Several large prints of montages hang in my home, and most people assume they are paintings. I once created an audiovisual show of slides with music, made up entirely of montages from a cemetery. The gravestones had a decidedly ghostly appearance! This is clearly an area of photography where you can achieve a wide range of visual effects. AG

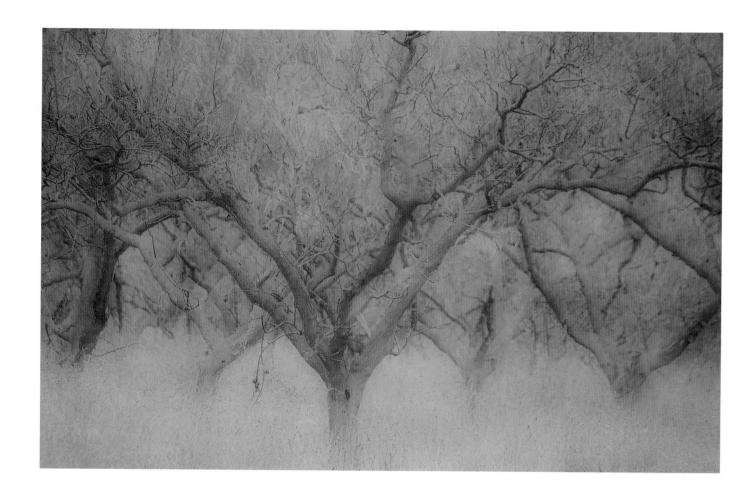

One overcast day in the New Zealand countryside I came upon this orchard. I was struck by the blending of its colors, intensified by a light rain. I got out of the car and backed away from the scene so I could use a longer lens to compress the trees. The montage, using two pieces of film, added the element of surrealism.

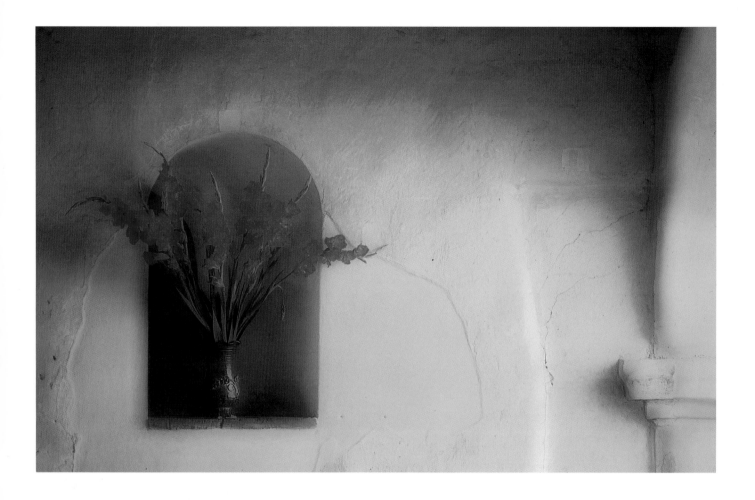

When in Mexico, I peek into every courtyard. Once, in Oaxaca, I wandered into a small hotel, looking for a courtyard, and found this glorious bouquet of gladioli in a small alcove. I knew the red of the flowers would stand out against the pale color of the wall and that the glowing quality of a montage would emphasize this. I backed away as far as the opposing wall would allow, so I could use the longest lens to produce the softest blur in the out-of-focus layer of the montage.

One wet, cold day in May, I decided to do some photography indoors and chose to concentrate on tulips I had grown, using montages. With borrowed blue bottles on the window ledge and the tulips arranged in them, I used a reflector to bounce some light onto the still life. I took the first image in focus at f/11 (I did not want detail in the background) and overexposed by two stops. Then I threw the scene out of focus, set my aperture wide open at f/5.6, and overexposed by one stop.

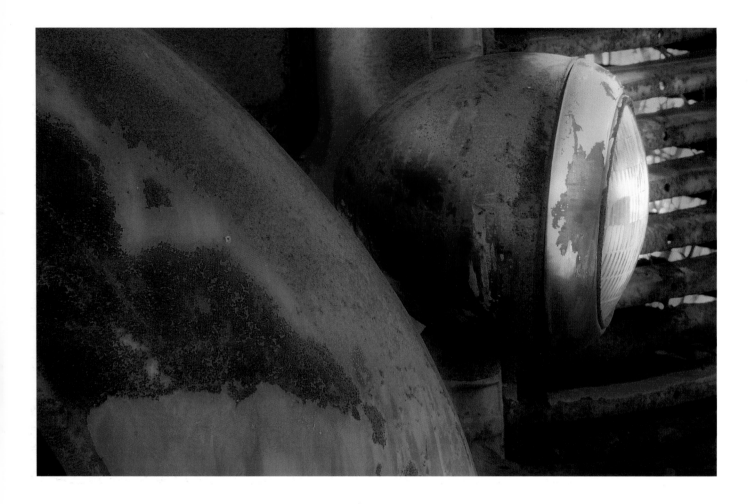

This is one of the more representational images I made in an old car lot. I wanted to add a quality of abstraction to the partly shiny, partly dull corroding metals. The glowing quality of the montage works well with the mixed colors of the rusting, abandoned car, and the brightness of the headlamp adds contrast. The in-focus image was shot at f/22 and over-exposed by two stops, while the out-of-focus picture was shot at f/5.6 and overexposed by one stop.

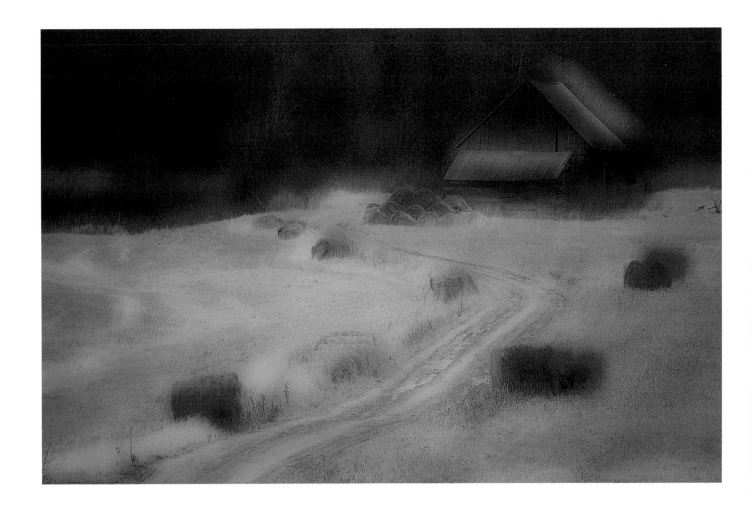

A more recent montage, and one where I used three pieces of film. The first photograph, in focus, was taken at f/22 and overexposed by two and a half stops. I then threw the image out of focus and took two more shots, the first one over-exposed by one stop and the second by one and a half stops. The montage added a mystical quality to this otherwise ordinary scene.

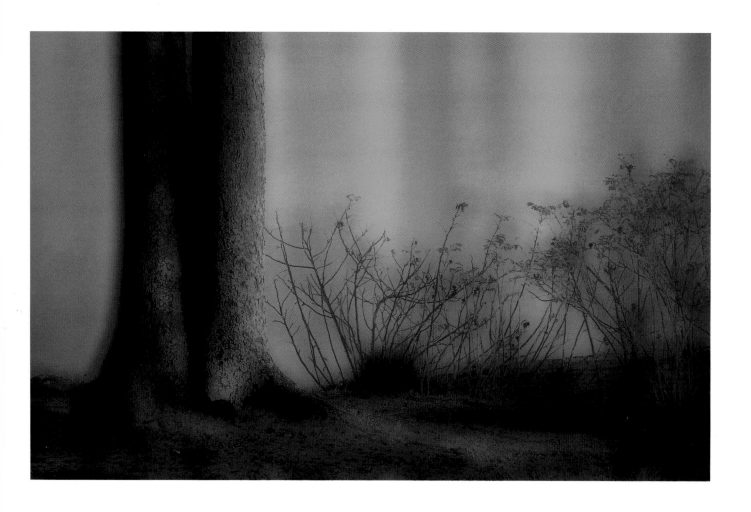

In this montage of a tree trunk, which uses three pieces of film, the water in the background takes on a surreal appearance as it reflects several brightly painted ships in the early morning light. I wanted the image to glow.

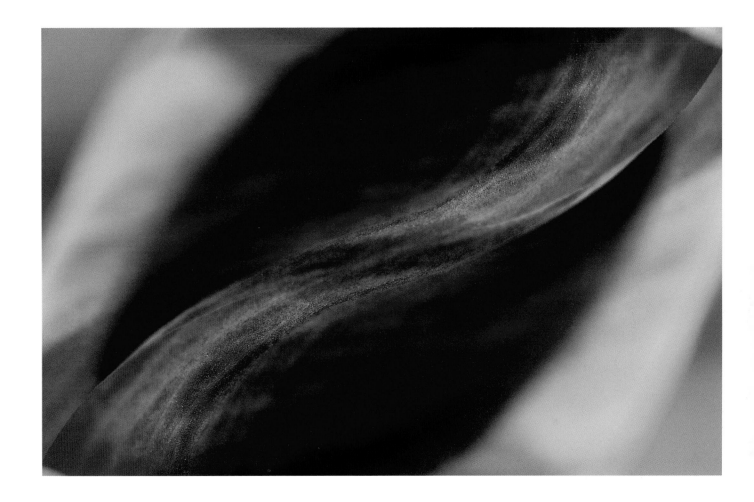

In my breakfast room, where light is plentiful, I took a series of pictures of a single purple iris. Many were extreme close-ups, and I was in the mood for abstraction that day. I overexposed some of the images by one stop, and made sure to take two identical shots as I planned to do reversed montages, where one image is flopped over the other. It is no longer an iris. Is it important what it is?

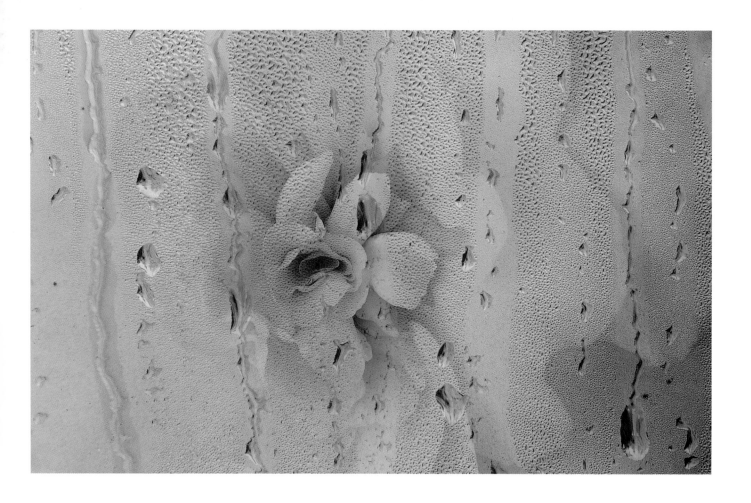

Two images were combined to produce this montage. Both are very light in tone and neither of them is overly busy. The hues are harmonious: the center of the white begonia is yellow, while some of the water drops on the windowpane happened to pick up reflected color from a nearby maple tree that had turned yellow in the early autumn.

Subtle and vibrant colors

I am not interested in color for color's sake and light for light's sake.
I am interested in them as means of expression.

ROBERT HENRI, "THE ART SPIRIT"

Color is tied to passions.

ELTON JOHN

In your imagination compare a black-and-white drawing of Dante's inferno with a drawing that is rendered in hues of scarlet, crimson, orange, yellow, burgundy, and black. There is probably little doubt as to which will make the more vivid impression. Nevertheless, you don't need colors to identify the black-and-white drawing as a depiction of Hell. Lines and shapes tend to identify objects and situations, while colors tend to influence your emotional response to them, often very markedly indeed.

Canadian photographer Robert Bordeau, whose photographs I have respected and valued for years, has worked primarily with large-format, black-and-white negative film. I remember viewing some of his gentle landscape images thirty years ago and being deeply moved by the subtlety of tones and their transitions into one another. The new grasses of spring were tonally integrated in remarkable tapestries. I could feel in the tones what I could not see: the subtle yellow-greens of spring, the wisps of palest brown, beige, and straw. But had I stood in the same spot as Bordeau, I would have

felt extremely frustrated if I had been unable to shoot color. And it may have been then that I first realized I am a black-and-white photographer who needs, emotionally, to work in color.

Varying degrees of brightness, or tones, are vital to every composition I make. I never underestimate their role in establishing the structure of a picture, and I am as moved as ever by gentle tonal transitions; but color, in hue, saturation, and brightness, is a gift that I accept and work with joyously. I realize that my reactions to colors are personal. Some will share my emotional response; others, of course, may not. If you feel that your images come close to what you set out to achieve, you must not be afraid to honor your feelings and say quietly to yourself, "Well, *I* like it!"

In a discussion with a woman from Trinidad, she bemoaned the colors of November, which left her feeling bleak and empty. I, in contrast, was celebrating the huge variety of secondary hues, especially the enormous range of browns, and their variously intense or delicate beauty. Differing life experiences generate different

responses to color. If you open yourself to other re-sponses, they will both enhance your visual perception and deepen your awareness of other people's sensitivities and motivations. Equally, your personal attraction to certain colors and use of them in your picture-making indicate important things about who you are. Your use of color is one way in which you tell your life story.

Although color associations are to a considerable degree learned, colors themselves affect each of us directly. They do this not only by the information they provide but especially by the personal feelings they generate. Yellow may suggest one thing in a certain culture and something quite different in another. In western cultures, blue may symbolize anything from depression ("I'm blue") to majesty (royal blue). Although some people seem to find particular shades of blue depressing, you may find it is certain greens that have a negative effect on you. The variations are almost endless. If you choose certain hues primarily for what they symbolize, you are putting your own feelings second, which is something no self-respecting artist will do. Instead, you should honor your own feelings, and work with the hues, saturation, and brightness that you naturally choose, rather than attempting to please others (except in the case of a commercial assignment, where your client may literally "call the shots").

A photographer-friend of mine who has lived for many years in the desert countries of Namibia and Israel told me of her initial reaction to the rampant mix of brilliant reds, oranges, and yellows of the eastern North American autumn. She was overwhelmed – just like many people who see, for the first time, Earth's most lavish and stunning annual display of brilliantly colored wildflowers in Namaqualand, South Africa. Those not accustomed to these places can find it very difficult, if not impossible, to deal with the visual overload, which is really, from their emotional standpoint, a temporary inability to cope with an overabundance of color. Faced with such a visual feast, many photographers are instantly sated, and cope with their feelings by averting their eyes for a while – training their lenses on small things, such as a single flower or a branch of colored leaves, possibly for days. As they become more accustomed to the colors all around them, they gradually begin to photograph larger spaces. On the other hand, I've noticed that people who move to a very monochromatic landscape from one that is more varied in color will often paint the walls of their new home in more vibrant hues than the walls of their previous home.

If you don't have days to adjust to color, however – if your bus rolls at daybreak – what do you do? This is when "abstracting" is essential, although it's at the root of any good composition. Abstracting is nothing more than observing, in the space you want to photograph, how the tones and colors form shapes and lines. It's taking the labels off the subject matter and seeing it as pure design – not as a boulder but as a circle, not as a field but as a rectangle. When you study a scene carefully, no matter how detailed it may be, you will usually find that it can be abstracted into one to five shapes. Six is rare. Two, three, or four are most common. So, faced with a hillside of flaming leaves or a vast sweep of flowers, look for the places where yellows blend into oranges, or darker tones of red blend into lighter ones. If you can spot the transition lines, however subtle, you will be able to identify the component shapes and compose the scene effectively in your viewfinder. The changes between areas of color and/or tone, or between different

textures, will frequently be very clear, which makes abstracting and, therefore, composing easy.

Although color has emotional impact, remember that we are able to distinguish shapes and lines only because of contrasts between colors and between tones. Designing or composing your image in a wildly colorful situation is not so difficult as long as you remember this simple fact.

André and I each enjoy working with both subtle and vibrant colors, but we differ in approach. André is strongly attracted by the rich, glowing colors of Mexican villages, especially those hues found early and late in the day, but in 1999 he gave himself a personal assignment: to shoot at least one roll of film, out of doors in southern New Brunswick, every day from late November until nearly Christmas. A national magazine published eight images from this "dullest" month of the year. I, on the other hand, have a natural affinity for November's hues and am deeply affected by the washed-out beiges, pale creams, and spotty grays of dying hosta leaves. Nevertheless, I've traveled more than twenty times to Namaqualand to photograph its amazing color spectacle. It's a matter of personal emphasis: André's first love is vibrancy, mine is subtlety. Like most people, though, neither of us has an exclusive emotional preference.

Both vibrancy and subtlety are a matter of brightness (tone) and color saturation as much as or more than they are a matter of hue. We often think of red, blue, and yellow, the fundamental primary colors on which the sense of sight builds the organization of color patterns, as being vibrant. However, they lose their vibrancy at various levels of saturation and brightness, such as when red is rendered as light pink (more brightness, less

saturation of hue). And certain secondary colors can never be really vibrant no matter how saturated they are, brown being perhaps the best example. In most natural situations you have to work with the colors you find, and if you want to alter their appearance or intensity, you can usually do it far more easily by exposure – lightening or darkening colors – than by increasing or decreasing the saturation. It's impossible, for example, to add more chlorophyll to leaves.

By using filters, colored gels, and lights of varying color temperature, you can affect color saturation in an image as well as actually alter a hue itself, depending on which filters or similar aids you select. Sometimes the effect is more apparent than real, but the visual effect is what counts. For instance, if you are photographing a field of red huckleberry leaves covered with sparkling dew, a polarizing filter will reduce or eliminate the highlights (when the lens is pointed more or less at right angles to the sun), and this will seem to make the reds more saturated and vibrant. In fact, as much as anything else, you've eliminated tonal highlights that were competing with the color for visual attention, and the red now fills in all the formerly highlighted spaces. Technical arguments that may arise about what actually happens are irrelevant. What you see is what matters.

Other filters, such as the 81A and 81B warming filters and the 82A and 82B cooling filters, add hue to the overall image. Split filters, of course, add hue to part of an image only and are often used to intensify the colors of the sky, for instance. Neither of us much cares for the effect of these filters, because to us the resulting colors always seem so false and the use of the filter so apparent. But they are widely used. Experiment with a new filter until you have enough photographs to make

an intelligent judgment about what you generally like, but also to identify special situations where you might want to use a filter whose effect you normally dislike. Remember that your personal preference is paramount, especially when you are endeavoring to convey not literal or documentary information but a feeling, a mood, or some other intangible quality.

Every photographer knows that the color of light changes continuously from warm to cool to warm as the sun rises, moves to its apex in the sky, and then descends toward the western horizon. In either hemisphere the sun's light is coolest (bluish) in hue at about noon in summer and warmest (slightly golden) at noon in winter. The farther north or south you go, the warmer winter's noonday light is and the cooler the hue of the shadows, which are always the reverse color of the sunlight. The color-contrast intensity is often much greater earlier and later in the day, though the brightness-contrast intensity usually is not. Imagine the varying appearances in color and brightness of tree shadows falling across snow at various times of the day.

The light on overcast days tends to be more color-neutral year-round. Under an overcast winter sky, if you expose correctly and avoid films or filters that give a color cast, you can get really white snow throughout the picture space, something that is much more difficult to do when the sun is shining.

When you make multiple exposures, you will frequently alter the rendition of colors from those that occur naturally, or that appear to your eye to be present in the scene or situation. This happens primarily because you are moving your camera in a certain way during the exposure of several images, one on top of the other. As a result, you cause colors to overlap to a greater or lesser degree — in all or part of the image space — unless you are dealing with only one hue. Even with a single hue, you will change the rendition if the hue has a range of tones and/or saturations. A single-exposure photograph made on a sunny day of a very green row of trees or shrubs may show a good deal of black shadow between the leaves, but the contrast will be reduced when you overlap the tonal areas, that is, when you make them out of register with each other in successive exposures, because brightness (tone) affects color rendition. The mood or feeling evoked by the color renditions in a multiple exposure will differ from that evoked by a "straight" shot, sometimes markedly.

Your best teacher in this matter is experience. You can study other photographers' multiple-exposure pictures for guidance, but there is no substitute for doing your own trials and making your own errors. You will never learn how to blend colors exactly, but you will gain a good sense of what is probable. And when an image turns out to be very different from what you expected, you will sometimes be so delighted with the result that you will want to study the image and recall the situation carefully, so you can repeat the effect at a future time.

Much of the preceding information about color is as applicable to documentary photography as it is to impressionistic work. Before I address the question of whether or not you can use color to make a magic leap from one type of photography to the other, I want to reiterate clearly my conviction, stated in the introduction, about the value of fine documentary image-making. I deeply respect photographers who devote their efforts to representing physical authenticity, or to conveying the literal or objective reality of things

external to themselves. Frequently, they are doing very important work. Photo impressionists are just as concerned about conveying objective reality, but their subject matter is different; it is the reality of their own feelings. Perhaps it is even more accurate to say that it is how they feel about what they see. This may mean that a photographer uses physical reality simply as a vehicle for what he or she is feeling, which may be quite independent of the reality. Or it may mean that the physical reality, the stimulus for the photographer's feelings, is "affirmed" by that person, who treats the reality with loving, if not literal, care.

In either case, can color function as an aid or tool for creating impressionistic statements? My personal answer to that is a definite "Yes!" The colors created or modified by photographers who make multiple-exposure images, blend hues by panning and blurring and selective focusing, lighten or darken colors through exposure manipulation, or use other techniques and tools — according to the instincts of their imagination and emotional responses — are not necessarily personally expressive, but they certainly can be when used by an experienced artist. Several of these techniques will be covered in the chapters "Familiar techniques" and "Trends." **FP**

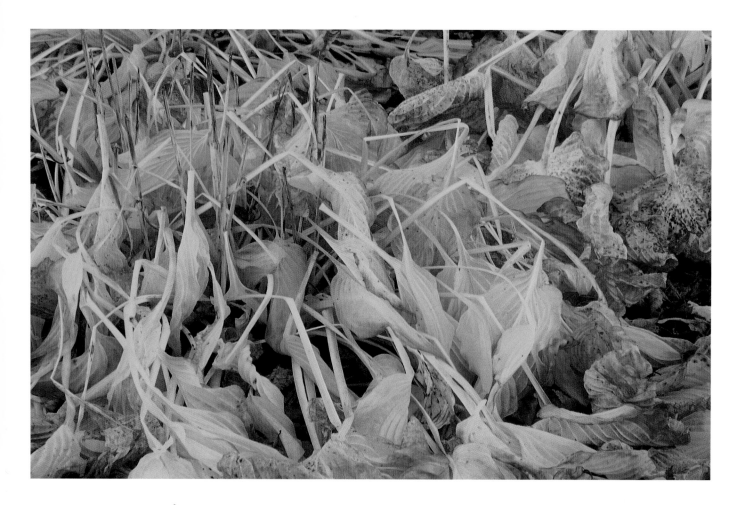

Colors like this – desaturated secondary hues that are light in tone – have an emotional appeal for me that I've never tried to understand but simply enjoy. I'm especially fond of compositions that contain a single hue, or at the most two. On the whole, these subtle colors appeal to me far more than saturated primary colors, especially when reds, blues, and yellows have been photographed in very bright or harsh sunlight. Perhaps it has something to do with the fact that I appreciate restraint.

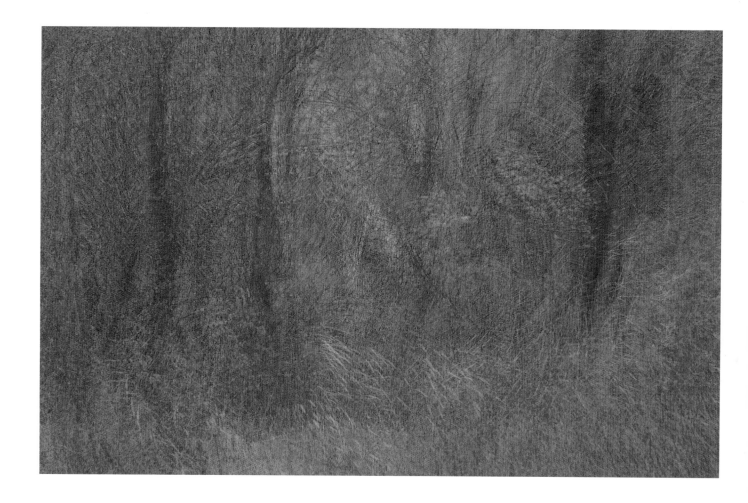

One November day I made this multiple exposure as part of a month-long assignment to photograph along a short stretch of road near my home. (Four other images from that assignment appear on pages 107-9.) In the actual scene the contrast was greater between the tree trunks and the paler branches and grasses, but while the range of tones was considerable, the only hue was brown. I realized that by moving the camera up and down very slightly during nine exposures and giving it a tiny twist for about two, thus blending the tones, I could come close to what you see here: a softer, gentler transition between the roadside grasses and the forest behind.

In literal fact, a greenish path cuts across a field of browning grasses, but I had the impression – and the feeling – of a barely perceptible path wending through an incredibly delicate dreamscape. To convey this on film meant desaturating the greens and lightening the tones overall. I accomplished this by making nine or so exposures while hand-holding the camera but moving it very little between them, and by overexposing the equivalent of one shutter speed or lens opening.

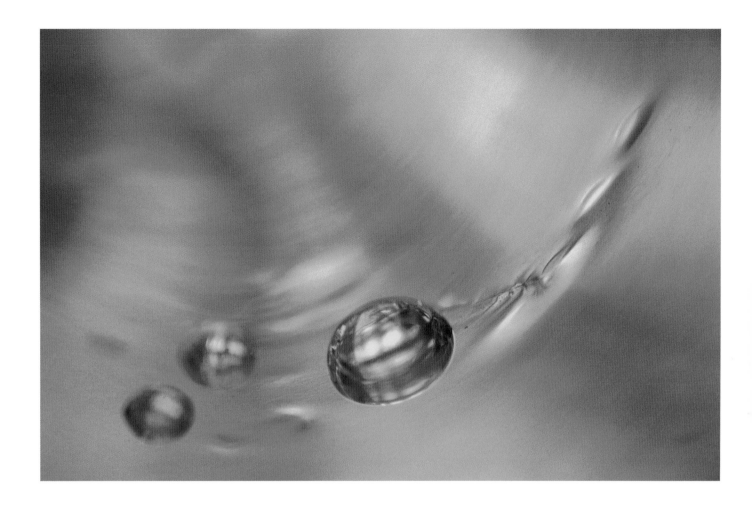

A sheet of aluminum foil or silver Mylar, reflections from a tumbler of yellow liquid and another of blue – these kept me busy all day. At one point I dipped my hand into the liquid and shook drops onto the foil. Photographing those consumed three hours or more. I overexposed slightly to retain the vibrant yellow hue, which quickly goes dull when rendered as a middle tone, although not enough to weaken the rich color contrast. The photograph is quite literal, and for me any sense of impressionism is created by the shallow depth of field.

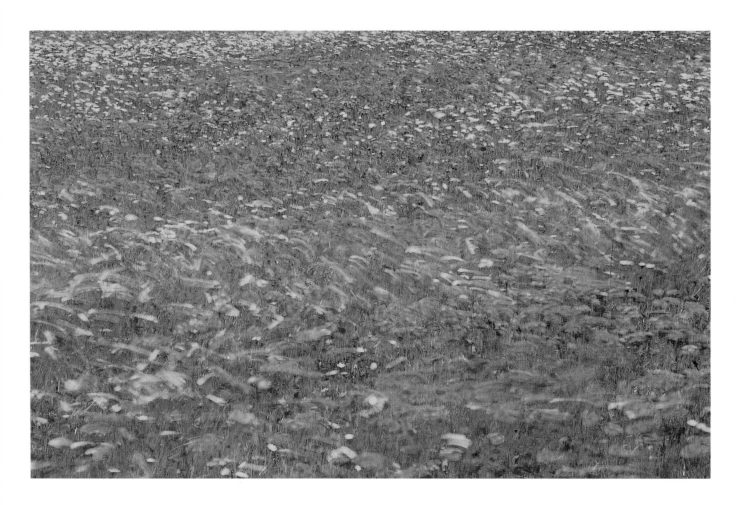

Every year the farmer who owns this field of red and yellow hawkweed leaves it unmowed until the flower spectacle is over. (He's my idea of a thoughtful farmer.) The vibrant colors arrest the eyes of photographers and non-photographers alike. On this very windy day I chose slow-speed film and a neutral-density filter, and selected the maximum lens opening of f/22 to enable shooting with the slow shutter speed of $1/4$ second. As with the yellow daisies (page 24), I wanted to convey the sense of the wind buffeting the blossoms, but the technique used here is different.

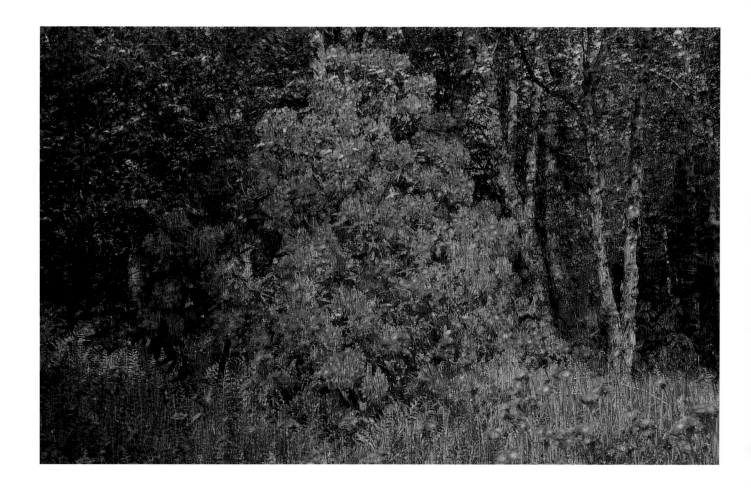

Two years later I again photographed the field shown in the preceding image. This time I combined one of the images (which I had overexposed by one shutter speed or lens opening) with a very overexposed picture of a pale pink rhododendron bush blooming in a woodland glen behind my house. The hawkweed dominates the shrub and the white trunks of the birch trees, creating a magic forest. Only adults try to figure out what's going on; children never do. The question arises: when is fantasy fact?

Choosing a film to create a mood

Photographs really are experience captured, and the camera is the ideal arm of consciousness in its acquisitive mood.

Susan Sontag, "On Photography"

A photographer chooses a film in much the same way that a painter picks a color to add to a canvas.

On assignment on the small island of Nevis in the Caribbean, I knew the sun would shine most of the time and the colors would be varied and intense. I chose Fuji Velvia for its sharpness and color saturation. It captured the beautiful turquoise of the sea, the vibrancy of the fuchsia bougainvillaea, and the lush greens of Mount Nevis's rain forest. For a subsequent magazine assignment in Morocco, the art director and I agreed that the shoot should be done in black-and-white. We felt this would free viewers to notice contrasts and character in the images instead of "wowing" them with strong colors. A golden hue was then added to the images to emphasize the warmth of this exotic location. "Moroccan Mysteries" won a National Magazine merit award for photography, thus reinforcing a good choice of film.

In this chapter I'll talk about various films and their characteristics, and why I choose them for creating different moods and photo impressionistic effects.

Color slide film. Slide film is the format customarily used by the magazine and book publishing industries, and Freeman and I use it for most of our photography. We use either Fuji Velvia (ISO 50) or Kodak E100VS (Vivid Saturation) because, with both films, grain is minimal and the colors are saturated. Freeman is particularly struck by Velvia's capacity to accurately render both subtle and vibrant hues under overcast and shaded conditions. If he's not shooting Velvia, he shoots Kodak's E100VS because he likes its rendition of most hues throughout their entire tonal and saturation range. It's also Freeman's favorite multi-purpose slide film for recording pure white. The two images of snow-covered trees on pages 108 and 109 demonstrate why Freeman feels this way.

I use Velvia extensively. I know the film so well that I can predict its response to light and color. I too love its vibrant saturation. I use the film for all subject matter, including montages, for its sharpness and punchy colors. My one reservation about Velvia is its rendering of people. In my view it does not reproduce skin tones

48

accurately, and any red marks (blemishes, pimples, or a red nose) are emphasized.

The more I get to know Kodak's E100VS, the more I like it. Offering a slightly different color palette from Velvia, its saturation of hues, especially the blues, is wonderful. This film is an excellent choice for photographing people, nature, and landscapes; and at a speed of ISO 100 (with pushing capabilities) it's ideal for shooting wildlife and aerials.

There are many other fine color slide films available, such as Fuji Provia 100, Fuji Sensia 100, the Kodak Ektachromes, and Agfa's RSX 50 or 100. Find one or two that you like and get to know them well.

Grainy film. I cherish the mood created by coarse grain in photographs: the rendering of soft, subtle colors, the impression of timelessness, the peculiarity of a film's imperfections. With advancements in technology, film manufacturers are producing sharper films with more color saturation. Some of us are missing the beauty of grainy films. Agfachrome 1000, which disappeared a few years ago, was unrivaled for its grainy appearance, but there remain a few films that will produce some grain in your photographs. In slide format there is Kodak Ektachrome EPH 1600 and Fuji Provia 1600. Kodak Royal Gold 1000 is a color negative print film, and Kodak TMax 3200 and Ilford Delta 3200 are black-and-white negative films.

The best way to obtain grain is to use high-speed film and rate it at two stops over its indicated speed, for example, ISO 400 exposed at ISO 1600. Because you are underexposing the film, it will have to be "push processed" by two stops, with the film being left longer in the developer to compensate for the underexposure.

This results in grain buildup. When I make photographs using this technique, I add a diffusion filter to my lens to further soften the image and enhance the romantic ambience. See the photograph of Castle Stalker in Scotland on page 52 or the beauty shot of Julie on page 54.

Select subject matter that lends itself to this type of imagery: a castle enshrouded in mist, a rainy street scene, a model wearing an elegant, flowing gown. This combination of film and technique works best on cloudy days, at dusk, and at dawn, when lighting is soft. When the light is strong and the contrast high, the film does not perform well, so refrain from using this technique at those times or try to photograph in shaded areas.

A few years ago I had an assignment to photograph a story on the pilgrimage to Santiago de Compostela in Galicia, in northwestern Spain. With frequent rain (two out of three days) and consistent fog, the weather conditions were ideal for working with this technique. The grainy images added the right atmosphere to the story. Painterly images – a church on a seaside cliff in the rain, ominous clouds towering above the Cathedral, a statue of the Virgin Mary holding her bruised son – were chosen to illustrate "The Edge of the Earth," a story about a land of rituals and melancholy.

I've since shot several travel stories using this technique. I'm also building up a collection of "grainy" images, photographed mostly in Europe. To ensure consistency in the images I always use the same combination of film and diffusion filter. This way I can add to the collection while preserving the same atmosphere in photographs taken years apart. This technique, when used with the right subject matter, can produce images that are both alluring and evocative.

Color-processed black-and-white film. Kodak T400 CN, Ilford XP2, and Konica VX Monochrome are black-and-white print films designed to be processed using C-41 chemistry, color print film processing that is available virtually everywhere. They are great films and ideal for people who like black-and-white but do not have access to a darkroom. With a speed of ISO 400, very little grain, and excellent sharpness, these films are versatile and easy to use. The negatives can be printed on black-and-white paper for a pure black-and-white print, or on color paper with a choice of hues. I find the light brown hue, similar to a sepia tone, very appealing.

These are excellent films if you are venturing into people photography. Their speed will allow you to hand-hold the camera for candid photographs (although I advocate using a tripod at all times) or to keep up with kids as you take pictures of them running around and playing. The films are fast enough to photograph indoors using soft window light, which is ideal for portraiture. They're also versatile films to take on your travels.

I've started to photograph a series of images using my Hasselblad (I love the square format) and Kodak T400 CN. My aim is to capture the spirit of the final days of summer: a canvas chair on an old wharf with mist in the distance, a basket of apples on a worn table, a little girl walking in golden grasses with a bunch of gladioli. I print these images on watercolor paper, and to the brown-hued photographs I add a faint touch of color, as in the image of the old chair in the garden where only the apples have been colored (see page 57). With a hint of mystery, these images are my impressions of a change of season, of "Summer's End."

Black-and-white infrared film. This film produces particularly surreal images and is an excellent choice if you are looking for something unusual and exciting. The most popular black-and-white infrared films are Kodak HIE, Konica 750, and Ilford SPX. Kodak's HIE (high speed infrared) is the most sensitive to infrared and renders the most surreal images. This type of film demands more care in handling because of its high sensitivity to light. It is also susceptible to fogging, and must be handled in total darkness. When you combine the film with a red filter (Kodak Wratten #25), the images become transformed: in landscapes, blue skies appear ominously black and foliage turns white. The effect is both dramatic and magical.

I discovered the qualities of infrared film while photographing gardens in Spain. Although I was doing the shoot in color, the dryness of that summer, combined with the lack of flowers, motivated me to experiment. One hot, sunny afternoon I photographed using Kodak HIE in the Maria Luisa Park in Seville, capturing fountains, park benches, and pergolas. I was extremely excited by two swans on a pond next to a gazebo. Once the roll was finished, I went back to my hotel room and unloaded the film in a dark closet. (A changing bag would have allowed me to switch films on the spot, but I didn't bring one because I had only a few rolls of infrared film.)

I finished the rest of the assignment in color, as required. Back from the trip, I processed the infrared film in my darkroom. The images captured the spirit of the Spanish gardens and, although the story ran in color, the art director was very impressed with the shoot, especially the infrared photographs that I had hand-colored.

When dealing with infrared film, always follow the instructions for exposure and development. As recommended, bracket your exposures, taking one or two shots over and under what the meter indicates. Once your image is focused, move the focus to the infrared mark (IR) on the lens (or focus a bit closer) before taking the photo. Infrared radiation does not come to the same point of focus as visible light.

On a sunny day, infrared film can change an ordinary scene into a wonderful dreamscape or transform an ancient graveyard or a waterfall into spellbinding imagery. The film is especially useful for photographing scenery where there is an abundance of foliage, as this is where you get the most infrared radiation.

Black-and-white slide film. Agfa Scala is a beautiful black-and-white slide film. Only a few professional labs process it (see www.agfa.com). The film, which has a speed of 200, can be pushed or pulled between 100 and 1600. It has a wonderful tonal range with very little grain, and is a very good all-round film. I love to use it when photographing people, as the absence of color allows a concentration on the features and character of the subject. Scala can be used the same way as any color reversal film for producing montages and multiple exposures.

On a trip to Paris, I took a few rolls of Scala with me so I could photograph the "city of light" in black-and-white. Walking along the exterior of Notre Dame, I was astonished by the stone creatures watching me. Gargoyles and grotesques in contorted postures with hollow, watchful eyes surround the massive cathedral. In awe of these haunting guardians, I felt I must photograph them. I decided to make double exposures, underexposing both by one stop, with the first exposure in focus and the second one out of focus to add a glow and a mystical quality to the images.

Because I knew Notre Dame is an extremely busy tourist attraction, I was first in line in the morning to ascend the tower. At nine-thirty I paid the entry fee and ran up the over three hundred steps to photograph the gargoyles on the ledge of this Gothic masterpiece. Out of breath, I had the extremely narrow place to myself. I was even permitted the use of my tripod until the place got crowded, which wasn't long. I spent the entire morning at the cathedral, moving from top to bottom, among these fascinating creatures. The stark black-and-white images on Scala film capture the aura I sensed under the menacing gazes of the gargoyles of Notre Dame de Paris.

These are just some of the films I use for impressionistic images or to create a particular mood. There are too many films available to mention them all, but I suggest you find a few that appeal to you and try them out. You may get exciting results: perhaps using a particular film in a particular way will produce a unique personal body of work.

Although I don't use all of these films regularly, each offers me something special in my photography. Experiment with these films for your own purposes, and try other ones as well. Your discovery of a film that thrills you is part of the creative process. AG

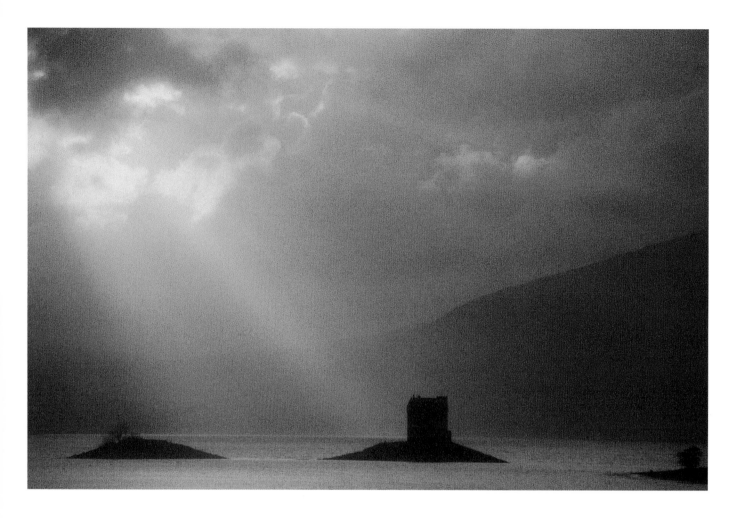

Castle Stalker in Scotland was photographed using high-speed slide film to enhance the appearance of grain. I also used an 81A warming filter, with a thin coating of hairspray, to diffuse the image still further. I love the dreamy quality added by the coarse grain. To get a similar effect you can use an ISO 400 film, shoot it at 1600, have the film developed at a professional lab, and tell them to push the film two stops. The lab will leave your film longer in the developer, which will cause the grain to appear.

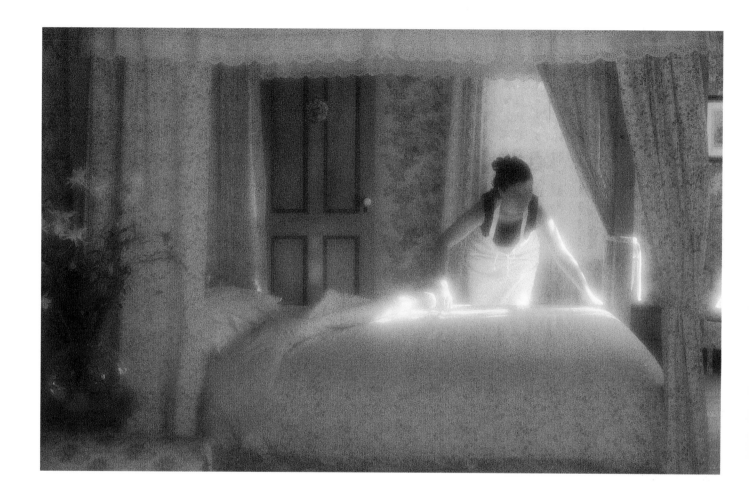

I was asked by a travel magazine to photograph the Eastern Townships of Quebec as a romantic getaway. I felt that grainy film would lend itself well to this type of story. I photographed this innkeeper making the bed early on a sunny morning. The high-speed film allowed me to hand-hold the camera, and the grain added a timelessness to the photograph. I always use a warming 81A filter with a bit of hairspray on it to achieve this effect.

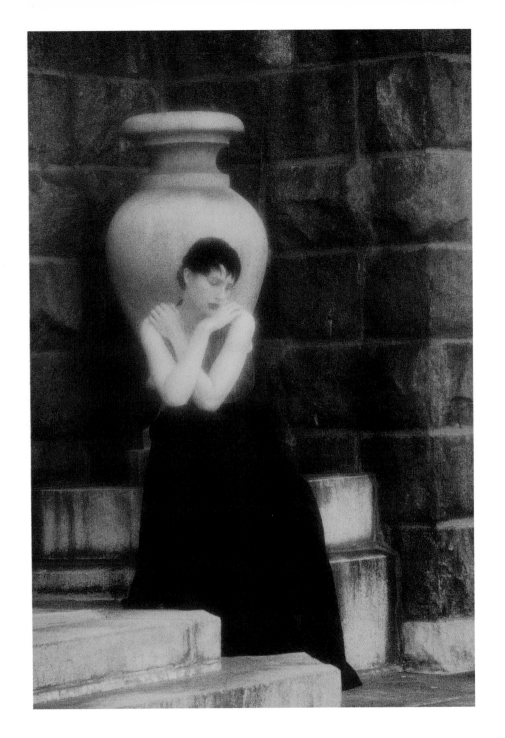

I've photographed my friend Julie on many occasions. A model, she always needs up-to-date photographs. Julie's mother lent her these beautiful classic clothes, so we decided to photograph in front of the cathedral in our hometown of Edmundston, New Brunswick. This setting seemed appropriate, and so did using a fast film for a grainy effect. I also used a warming filter, slightly diffused. The light source was natural with the aid of a reflector.

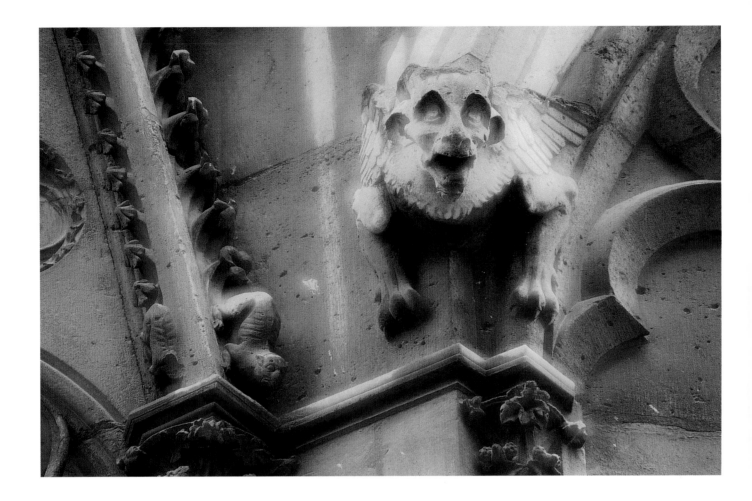

Agfa Scala is a black-and-white slide film I used to photograph a series of gargoyles that surround the Notre Dame cathedral in Paris. The image's slight glow was obtained by doing a double exposure. With the camera on the tripod, and using the double-exposure setting, I took my first photograph of the gargoyle in focus with good depth of field and underexposed by one stop. I then threw the image out of focus, opened the lens wide at f/2.8 and took the next shot, again underexposing by one stop. The slide came back well exposed, with a soft focus.

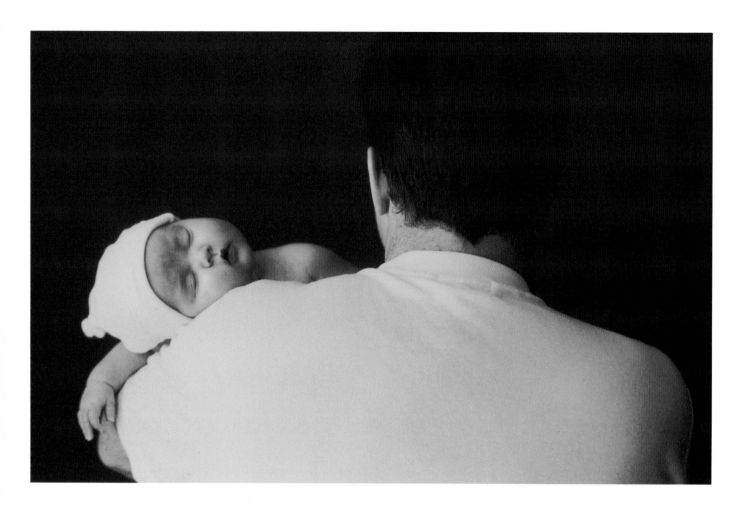

My friend and neighbor Michelle asked me to photograph her baby, Jaden. I took the photographs on Kodak's T400 CN, a black-and-white print film that can be developed in color chemicals just about everywhere film is processed. You can get your prints in black-and-white, or with a slight brown hue similar to sepia, a gold hue, or a hint of blue. With the camera on a tripod, I used available window light and was able to capture Jaden sleeping on his father's shoulder.

PHOTO IMPRESSIONISM

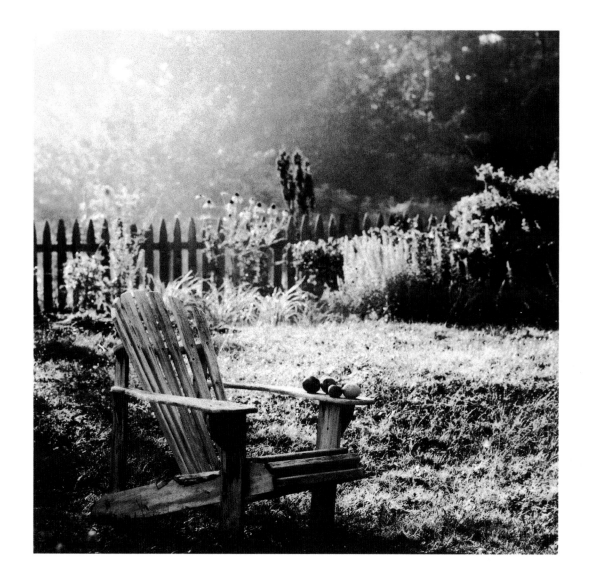

I frequently use Kodak T400 CN film. I love the effect when the images are printed on color paper, which imparts a brown hue. In this particular series I used medium format (120 roll film) and tried to capture the last days of summer. I also decided to add minimal color to the photographs in the series – in this case to the apples on the chair. I like the mood, and the bit of color adds mystery.

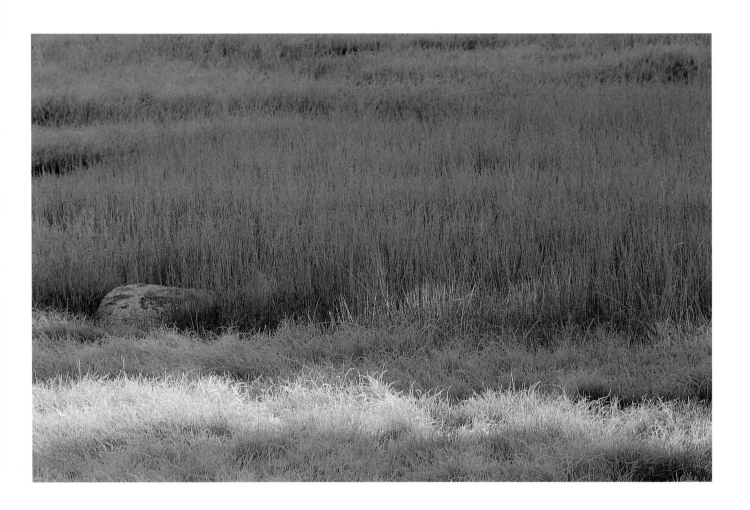

I was photographing with a friend on the shores of Nova Scotia, where the overnight frost had cast its spell. As we drove by this field, still partly in the shade, we looked at each other, knowing we had to stop. I used Velvia to record this image and did not feel the need to do a montage. For me the scene looks like a painting. It is a photograph where I can sense the delicacy of the grasses and feel the coolness of the frost.

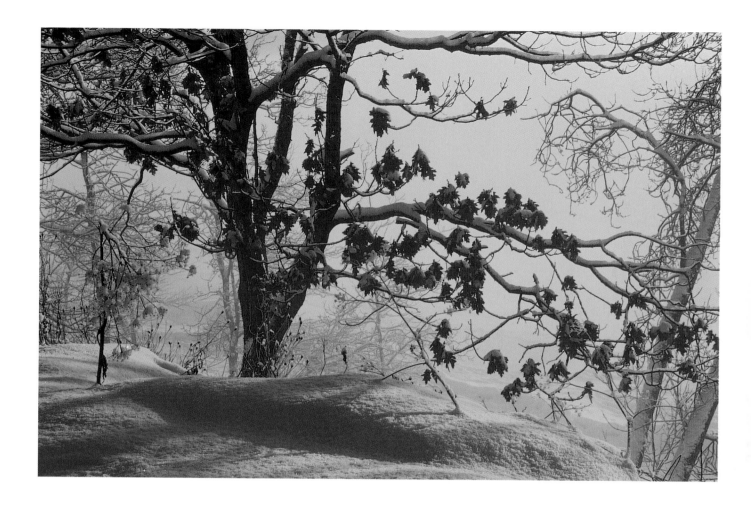

One cold morning I set out to photograph the effects of the sunrise on a nearby stretch of water. As I was getting ready to leave, I noticed this oak tree with its frozen leaves and the mist in the distance. I particularly like the way the snow takes on a cool blue hue in the shade. I used Kodak E100VS as I love its blues and clean whites.

Familiar techniques

Technique is to me merely a language and as I see life more and more clearly, growing older, I have but one intention, to make my language as clear and simple and sincere as humanly possible.

ROBERT HENRI, "THE ART SPIRIT"

Some basic and familiar camera techniques that photographers have been using for generations lend themselves especially well to the making of impressionistic photographs. These include, but are not limited to, overexposure and underexposure, fast or slow shutter speeds to create non-literal images, and selective focusing. Although all of them can be useful in making quite realistic pictures, it is their use as impressionistic techniques that we'll be considering here.

Exposure. Let's tackle exposure first, because it is usually the aspect of making pictures that most frightens beginners. They make mistakes, as we all did when we started off – and we still do. Some of those mistakes could have been very instructive if we hadn't thrown them into the garbage. Some of the worst exposures, viewed from the perspective of a couple of years' experience, may have been some of the best.

I remember a woman in a workshop I was teaching years ago who went into a dead forest to shoot the skeletons of trees. She made an error: on her camera she rated her 100-speed film at 25. You can guess what the forest looked like; it was drastically overexposed, washed out, and other things too horrible to mention. She threw all the slides into a wastebasket. Having earlier taken a peek at her films while they were drying in the darkroom, I rescued them. The spaces between the trees had gone virtually white, the dark edge of each tree had become a thin, dark gray line, and the whole forest resembled a spooky gathering of emaciated ghosts.

Later that day I showed some of the slides to the entire class, without revealing who had made them or what had happened. Everybody thought the effect was terrific. The next day the student went back into the woods and repeated her mistake – very deliberately. This time her overexposure wasn't a mistake; it was a creative technique. The class had destroyed her preconceptions, and now she wanted emaciated ghosts and knew how to make them.

Here's another mistake that went right: Before anybody told me how to expose properly for snow (that is, to overexpose by one and a half shutter speeds or lens

openings in most situations), I set off merrily following the guidance of my exposure meter. I assumed, of course, that it knew what it was doing. It didn't. At least, it didn't realize that I wanted my snow white, so it did what exposure meters are designed to do in every circumstance: it gave me middle gray. Most of the time I am not wildly excited by middle gray snow, especially since snow seems quickly to become that tone in cities. So I heaved my snow scenes into a wastebasket, all except one picture that I loved. I had been facing the sun because back lighting made the snow sparkle with diamonds, but I pointed the camera down a little, trying to avoid lens flare. With the camera set on auto-exposure, the meter did its nasty work, seeming to underexpose the snow drastically. And I still had some lens flare. But the effect I achieved was of diamonds sparkling on twilight dunes, with a shaft of silver light streaming down to illuminate a clump of grasses. Never, until this day, have I admitted my ignorance. Instead, I proudly showed the slide for years to "oohs" and "aahs" from many audiences. Another valuable mistake! One that I've repeated many times since in a wide variety of situations.

So, let's take a hypothetical situation. Let's say that you like light, airy, misty, dreamy, desaturated renditions of certain subject matter, and that you admire photographers who are able to achieve such a mood or rendition with considerable regularity. Let's also say that it's something you really want to do yourself, even though you don't know why. If you don't worry about the "why" but concentrate on the "how," on learning how to overexpose deliberately to the degree that you want in various circumstances, eventually you'll also discover why this visual approach matters so deeply to you. Getting to this point takes practice, and a lot of trial and error. There's

no formula, because subject matter varies, its original brightness varies, and what you feel about it varies from time to time and situation to situation. One day you'll overexpose so much that only traces of the subject matter remain; another day you will be extremely restrained. The joy is in the doing, in the feeling, not in rationally analyzing why you are doing it. It's okay not to know why until one day the answer presents itself, as it did with me and my exploration of textures (see page 12).

Shutter speeds. The photograph of the breaker on page 70 looks like a literal document. In fact, it is an impression. Nobody ever actually sees a close-up wave or breaker as sharply defined as this; we only think we do. Unlike cameras, our eyes can't capture or arrest nearby action at high speeds. So our mind tricks our eyes. The picture of the ocean at sunset on page 73 is more obviously an impression. The rapidly moving water is very imprecise, lacking in detail, with a misty quality. This photograph is a thirty-second time exposure. Nobody sees water – waves or waterfalls – like this either. The same is true of the photograph on page 71. Yet, aren't these impressions more accurate renditions than what we see with our eyes? By using time exposure for these pictures, and a shutter speed of ¼ second to record the flowers tossing in the breeze on page 46, I have captured what we cannot see with our human eyes but understand to be going on. Blurring may produce a more accurate rendition than sharpness does. My purpose here is not to argue which images are truly impressions and which aren't, but rather to demonstrate that varying shutter speeds produce very different visual and psychological effects when the subject matter is moving, in whole or in part.

Differing shutter speeds also produce a variety of impressions when the camera is moving at the time of exposure. For example, panning is tracking a moving object with your camera lens while using a slow, or fairly slow, shutter speed – ⅛, ¹⁄₁₅, or ¹⁄₃₀ second – when you press the shutter release. Since you will be pressing the release as you swing your camera, you will have to select the speed in advance. The general purpose of this approach is to keep your moving subject in focus and sharply defined while blurring the background. Thus, the person, animal, or machine stands out clearly against the background, which becomes entirely blurred. (See the image on page 124, which André made of a Moroccan cyclist.) To be successful it's important to press the shutter release "on the swing," as if you were hitting a softball or baseball; if you pause before you press the release, you defeat your purpose entirely. When you swing the camera and expose the film at a slow shutter speed *without* tracking a moving object – for instance, the image on page 124 without the cyclist – you would speak of blurring the subject matter rather than of panning.

You can use both panning and blurring to create impressionistic effects, but as with so many other techniques, practice will improve your chances of predictable success. Most children have both the willingness and the energy to act as models for one or two practice sessions of panning. Of course, you can practice blurring without help from anybody, and it's both a good idea and good fun to get "carried away." I remember one workshop participant who stood in the middle of a field, set his camera at a very slow shutter speed – to be activated in a few seconds by the exposure-delay mechanism – and swung the camera around him in a circle. He followed up by setting the camera for sixteen exposures on the same frame – that is, a multiple-exposure image – and repeated the exercise a few more times. That's how you learn. Don't be afraid to try.

Selective focus. I stopped my truck one autumn morning by a long, colorful stand of young maples. I couldn't park or photograph at the most colorful spot because of the danger from traffic, but as it turned out, I had no need to do that. Walking up to within a few centimeters of the maples, and using a 100-300mm lens, I aimed through the leaves at a spot in the near or middle distance on which I could focus clearly and distinctly – in most cases, more leaves, or perhaps a single leaf. The foreground leaves were almost like highly colored filters, because they were very close to the lens and extremely out of focus. In fact, in some compositions I chose to put nothing in focus. Since I had pre-set the lens at its widest aperture or lowest f/number, what I saw in the viewfinder was the exact composition I would get every time I released the shutter. (Remember, a single-lens-reflex camera always shows you a composition as it appears at the camera's widest aperture, unless you have the depth-of-field mechanism engaged and are using an f/stop higher than the lowest one.) After two rolls of film went whizzing through my camera, I switched to my 100mm macro lens and basically continued what I had been doing – converting another two rolls into pictures in seemingly no time flat, although in fact half an hour went by. In dollar terms it was an expensive morning, but in emotional terms it was a huge success. Altogether I exposed six rolls of film along a two-meter span of the forest's edge, and I returned to my vehicle on a real "high."

The reason I felt such a sense of well-being isn't difficult to understand. As I worked away, making compositions that I liked, I was saying more than "this picture is okay." Every time I released the shutter I was confirming, "I'm okay!" Every impressionistic photograph was an excursion into the reality of my feelings.

Anybody who experiments with a camera for even a few days soon realizes that lens openings of f/1.4, 2.8, and 3.5 don't give nearly as much depth of field as f/16, 22, and 32. You also realize that, when everything is in focus from the foreground to the distant background, your photographs tend to appear as literal renditions of the subject matter. Great depth of field in a photographic image – which is made with a single eye, so to speak – replicates human binocular vision, in which you are constantly focusing and re-focusing to ensure sharpness throughout your field of view.

It's a different matter altogether when you use "shallow" depth of field – that is, f/1.4, f/2.8, and other low f/numbers, depending on the lens. Usually, you have to focus very precisely to get the most important element of your image in focus. You also have to be aware of the degree to which other picture elements are "out of focus," because the visual relationship between the in-focus and out-of-focus components can be very expressive – and the particular effect may or may not be desirable. In either case what you're doing is composing an image that does not replicate human vision. Sometimes, however, you may end up with neither a likeness of what you see nor a likeness of what you feel. The important question is whether or not you have used the selective-focus technique to express the latter. In my view, photo impressionism always involves feeling, emotional response, or mood.

You may be able to conceive the composition of a selective-focus image, but you will never pre-visualize it accurately. In many situations you will want simply to poke your camera into certain material, as I did with the colored leaves, and start exploring. Focusing selectively is potentially just as useful if you're shooting across or through fabrics, concentrating on your dog's eyes while throwing its nose and the rest of its body out of focus, or examining the prismatic break-up of light rays in the interior of a paperweight.

Strictly speaking, all focusing is selective, regardless of what lens opening you select and how much depth of field you achieve. You choose to focus here and not there, on this object but not on that one. However, popular usage of the term "selective focus" means combining precise focusing with extremely shallow or narrow depth of field. The technique has acquired its own name, I believe, because it lends itself so easily to personal interpretations.

The design of the images on pages 72, 74, 75, 76, 77, 125, and 143 all depend on selective focusing. You can see that André has focused on the foreground on pages 125 and 143, whereas I've focused on the background on pages 72 and 77, the middle ground on pages 74 and 75, and have thrown everything out of focus on page 76, although some of the water drops are less out of focus than others. These photographs are chosen from thousands of selective-focus images we've made over the years, and there are many more we hope to make. For me, working with this technique allows the photographer to create a world that is visually related to the one he or she inhabits, but is different from it, often enormously so. Sometimes it's even like being able to live a fairy-tale existence. FP

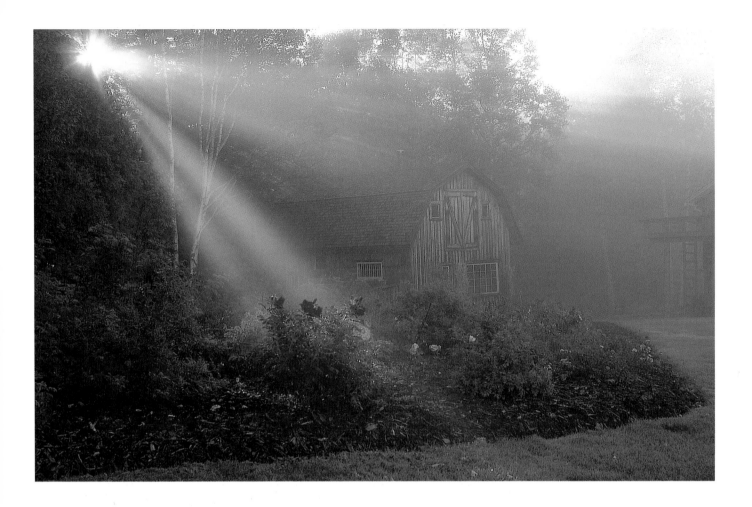

You may want to use spot metering for scenes that have a continuous range of tones from black or dark gray to pure white. A good beginning is to select an area that you want as a middle tone in the final image and follow the suggested meter reading. Then, meter off the "washed-out" area and calculate at least two stops of overexposure, and/or choose a dark gray area and calculate one stop of underexposure. If the three calculations nearly agree, you're home free. However, you should also assess the amounts and placements of dark, middle, and white tones, and decide subjectively whether to give more or less exposure to get the overall effect you want.

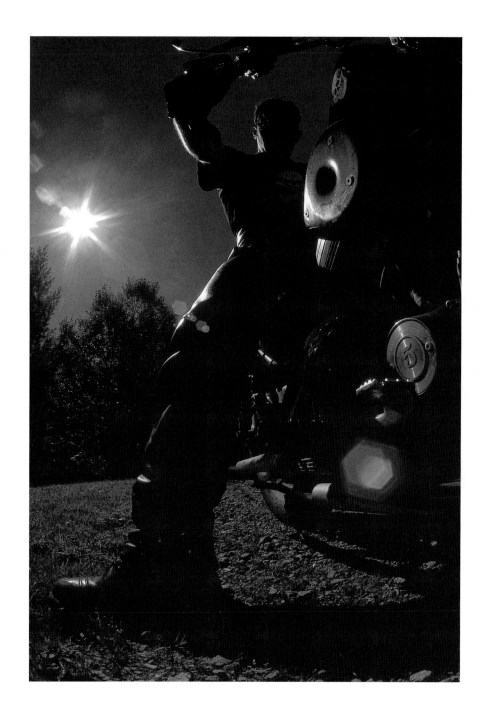

Substantial underexposure and the lack of fill-flash produce a rather ominous portrait of this biker (who, by the way, happens to be a high school art teacher). As in the images on pages 68 and 69, the extreme tonal contrast deprives the viewer of details, and it is this lack of information, coupled with the suggestive power of black, that creates an image which conforms to the somewhat stereotypical view of "the biker."

The saturation and brightness of the sunset reflected on the surface of the Dead Sea, combined with tonal transitions that formed delicate bands or lines in the water, stimulated a mood or feeling in me at odds with the physical reality. I seemed to be gazing down not on a dead lake, nor even a calm one, but on a sea of serenity. To convey this visually I overexposed, making an eight-second time exposure rather than the shorter one my meter called for. The longer exposure also helped to produce the sense of streaming in the darker water, which adds to the ambience.

66

André probably used considerable overexposure to capture the hush of dawn reflected in a creek, the surface broken only by an isolated clump of water lilies. I was not present when he made this photograph, but as a viewer of his image I feel tranquility and peacefulness. Was the physical reality – what André saw – different from what he shows us here? I have never asked him, and I never will. What matters to me is the impression that he has conveyed so successfully, stimulating my emotional response.

In my overall field of vision there were several large stretches of water spotlighted by the early morning sun, but of them all, this area was the most emphatic in its stark contrast. Even so, details in both the dark water surface and the hills beyond were visible, and the bright band of water appeared to be more "washed out" and to have less texture. My decision to underexpose considerably was based much more on what I felt that morning than on what I saw, although the actual scene both aroused my feelings and functioned as the "raw material" for my interpretation.

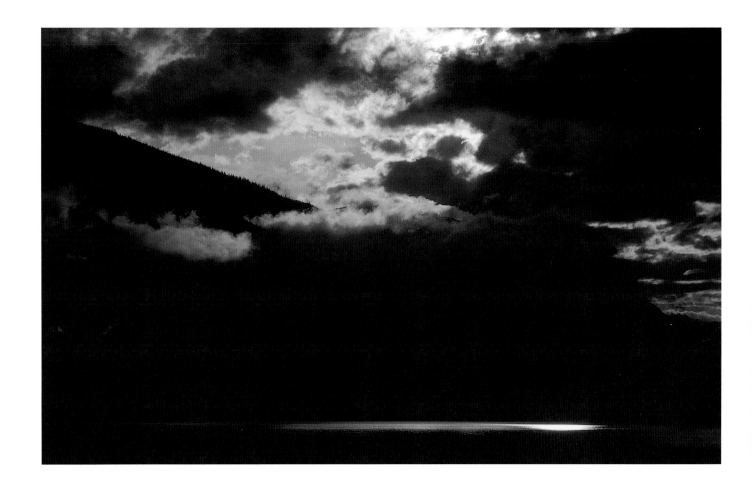

A similar scene and a similar interpretation to that on the opposite page, but made years earlier and half the world apart. Such extreme tonal contrast is beautiful on the one hand, yet often portentous or frightening on the other. For me it symbolizes the constant juxtaposition in our lives of the forces of light and darkness. Such extreme contrast is dramatic and potent for that reason. There is no middle ground here, no boredom. One senses creative power at work in the meeting of opposites.

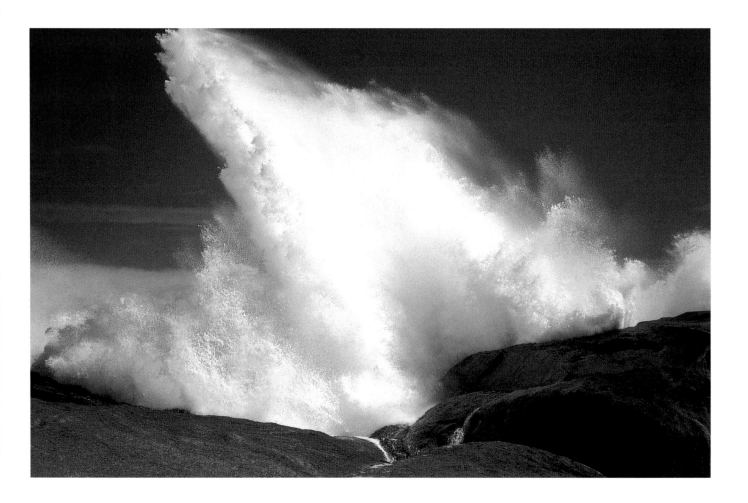

We never see an enormous wave or breaker in this way; we only think we do. This is clearly an impression, not a literal document, because it was made at a shutter speed of $\frac{1}{500}$ second, far faster than the human eye can operate. In actual fact the camera has made it possible to look at motion in a whole variety of ways that result from different shutter speeds.

There is no "correct" speed, unless one wants to argue that the speed at which an object is actually moving is correct. If such a picture were presented to us, though, would we accept it as accurate, or would we stick to our idea that this sharp, in-focus breaker is more "true"?

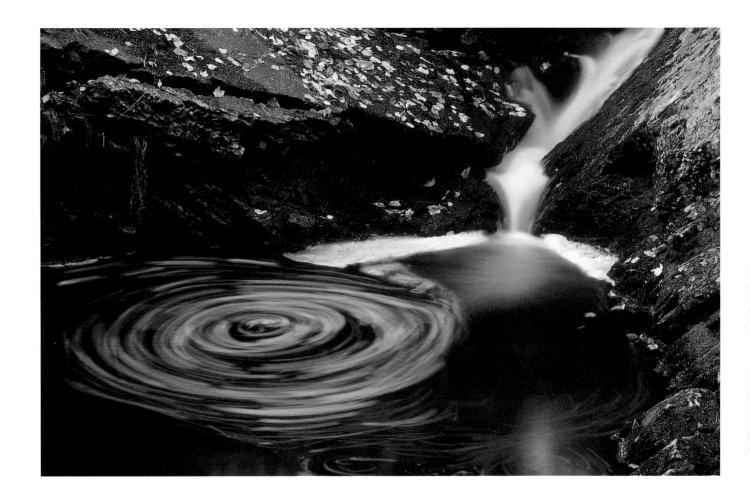

As I watched bubbles and bits of foam moving in a circular pattern, I had the mental, but not the visual, sense of a whirlpool. Because the viewer of the picture would not share my mental imagery unless I created visible circles, I used a lens opening of f/22 to necessitate a time exposure of several seconds. This photograph, like that of the huge breaker, is an impression of the scene that strongly raises the question of physical authenticity. Perhaps one must be satisfied to say that the pictorial representation is a real thing in itself, but only partly accurate as far as the scene is concerned.

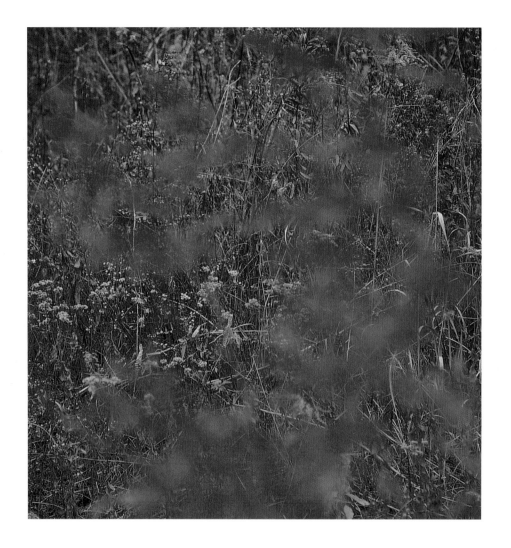

Focusing on the background of brown grasses and other plants, and using the shallowest possible depth of field, I moved in quite close to the red leaves of wild roses in the foreground. I wanted to give the impression of peering through the leaves, and indeed to see the background in this way, rather than shoving the foreground material out of the way, as I and others often do.

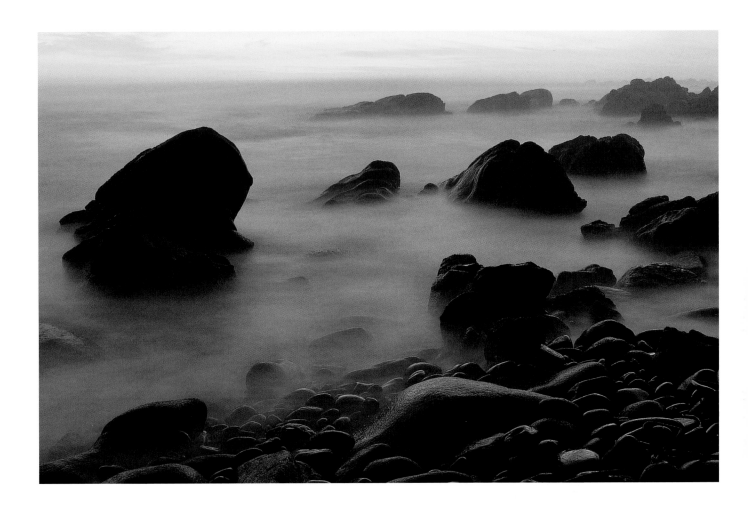

At the end of a splendid day spent photographing along the Atlantic coast of southern Africa, I sat in a small cove and watched powerful breakers crashing on the rocks. The ocean was thunderous, but I was in a state of bliss, feeling happy with the world and at peace with myself. Could I photograph the raging sea any more? Did I even want to? The answer was an emphatic "No!" So I photographed myself, as it were. Exposing film at f/32 for thirty seconds, I transformed the turbulent water into a dreamy mist through which the rocks appear as primordial forms.

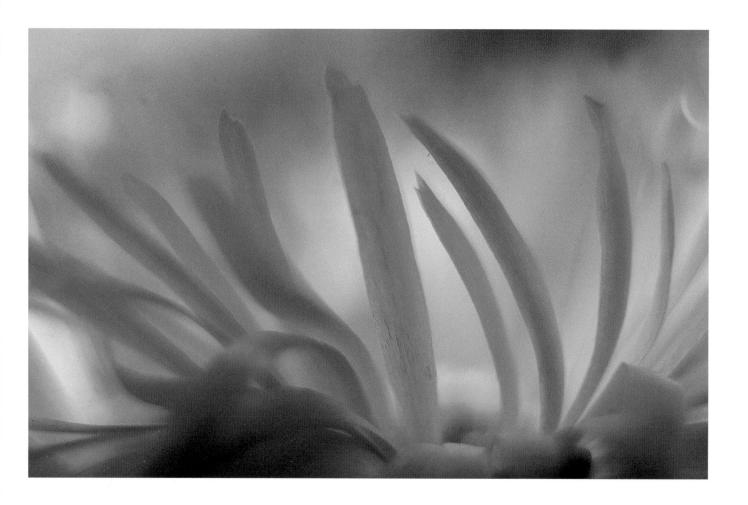

Both this image and the next one are extreme close-ups of flowers in which I used the shallowest possible depth of field and focused close to the "middle ground" of the composition. For this one I used a 28mm lens and an extension tube, which meant that the front or nearest petals were pressing against the front of the lens when I decided to focus near the middle. (Focusing in the precise middle would have rendered the stamens sharp, which, on inspection, I decided I did not want.) A photographer may choose to focus anywhere in such close-ups if the visual effect is aesthetically satisfying.

Every June at least half a million lupins bloom along my driveway and in the fields around my house. Color variations abound, which makes selecting individual blossoms for close-up investigation a delightful but daunting task. I photographed this one, a more common type, one morning when I had decided to look down the flowers from the top of their tall spikes in order to break the habit of viewing them from the side. It soon became apparent to me that using shallow depth of field and paying very careful attention to the point of focus would enable me to vary the presentation of the flowers even more. This composition is one example.

Very early one sunny morning I looked at my dew-covered flower garden and decided to make some pictures in which nothing was in focus. What I wanted was the magic, impressions of the vivid color and tonal contrasts, not descriptive images of flowers, leaves, and water drops. I could conceive vaguely of some possible images, but the excitement came as I poked my 100mm macro lens into the colorful mix. With my eyes and my lens wide open, I moved back and forth and sideways, aiming for the most part at material so close to the lens that I could not focus on it even if I tried.

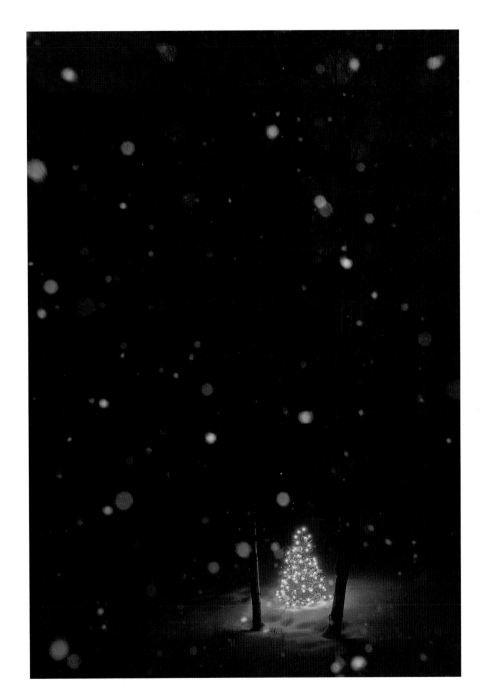

My focus here was on the lighted Christmas tree – the background, so to speak. The snowflakes, illuminated by an on-camera flash, would have appeared as hexagons or quite tiny points of light if I had used any lens opening other than the widest one. This is another example of a visual reality that exists in pictorial form but which we could never actually see with our eyes. However, the impression of the situation satisfies our mental image of a typical Christmas scene.

Trends

In addition to the techniques Freeman covered in the previous chapter, there are various trends and processes that are helpful in creating photo impressionism. Some of these, such as hand coloring and Polaroid transfers, you do *after* you've taken an image. These processes take photography a step farther. And the beauty is that everybody can do it.

Hand-colored photographs. Hand coloring a black-and-white photograph not only imparts a painterly quality but integrates your personal impressions through the colors you choose and how you apply them.

In order to color a black-and-white photograph effectively, the image must be printed on paper that can absorb oils or pencils. This precludes gloss or semi-gloss paper surfaces. Matte, fiber-based paper is the most receptive surface to work with. Here are some papers I recommend:

1 Agfa Portriga Rapid 118: Warm, this paper has a slight texture that makes it very absorbent.

2 Ilford Gallery: Neutral, with a very smooth surface. My favorite paper.
3 Kodak P-Max Art RC: Although not fiber based, it is a resin-coated paper designed for hand coloring.
4 Kodak Ektalure G-surface
5 Forte Elegance, Bromofort, and Fortezo

You may want to give a sepia tone to the print for a rich, warm look before adding color to it. To hand color a photograph you can use oils, pencils, or both. Marshall markets the oils and pencils in sets of different sizes. They also manufacture a pre-coating solution that makes the print more absorbent and a cleaning solution called Marlene, should you want to remove some of the oils. You can find these materials in good photographic or art supply stores.

For beginners I recommend pencils, because they're less messy than oils and easier to use for coloring fine details. The color won't be as uniform as it is with oils, but the finished print will have a nice feeling about it. Work in a well-lighted area. I prefer coloring during the

day, using natural light. Be sure to use well-sharpened pencils; keep a pencil sharpener handy. Apply color sparingly: it's easier to add than to remove. For a particular effect you can add color to the whole image or just to parts of it (see pages 82-83).

When using oils, again work in a well-lighted area so you can see clearly how they are affecting the photograph. Tape your print to the working surface; this will keep the paper from curling. Apply the oils with toothpicks, cotton balls, and Q-Tip swabs. A piece of white plastic, such as a margarine-tub cover, is useful as a palette, a place to display and mix your colors. Begin by hand coloring the large areas, preferably working from top to bottom. Dab a cotton swab into the first color you've chosen and apply it to the print. Then, using a cotton ball, rub the oil smoothly and evenly into the photograph until you get the tinge you want. The oil may spill over into other areas, but that can easily be fixed once colors overlap; the oils are opaque, so a new color replaces the former one. Move on to the next color, again working the larger areas and adding color from top to bottom.

The image comes alive as you color the details. Using toothpicks for detailing, add touches of oil to tiny areas. Absorb excess oil with a cotton swab until you are pleased with the tinge. Where two colors merge, make sure there is no excess paint by carefully rubbing the area with a cotton ball. Continue coloring until you achieve the desired effect. The oils take a few days to dry, so on the next day, in bright light, carefully inspect the print for flaws. You may want to add extra colors or perhaps lighten what you've already done. Once you're satisfied, allow the print to dry in a dust-free environment. The result will be a unique photograph that expresses your visual style.

Polaroid sx-70 manipulation, or Pola-painting.

sx-70 is one of Polaroid's many instant-developing films. With sx-70 there is nothing to peel away as the emulsion chemicals are contained within the print itself. The film was made for a camera of the same name. The sx-70 camera comes in different models — Alpha 1 and 2, sx-70 model 2, and Sonar se — and was very popular in the 1970s. You can still find these folding cameras in yard sales and antique auctions. I've been able to procure three this way. Fortunately, Polaroid continues to make the film for them.

After you expose an sx-70 film, it is ejected from the camera and starts developing, the image gradually appearing before your eyes. This is where the fun begins: you can alter the image as it emerges. The most obvious changes happen in the first ten minutes, but you'll have up to one hour to transform the photo before the emulsion hardens. This technique is called Pola-painting.

Put the exposed Polaroid instant print on a hard, flat surface. Using a fine burnishing tool (sold at art supply stores) or an empty ballpoint pen, press on the Polaroid's pliable surface. By manipulating the soft emulsion, you can move the chemicals and distort the image. As you apply pressure to the surface of the print, you can blend colors and obscure lines and detail. If you press hard, you can draw on the print, blurring existing lines while creating new ones. Pressing softly will give the illusion of fine brush strokes. The resulting image will be both impressionistic and unique, as the effect cannot be replicated.

I've used the Polaroid sx-70 to photograph common, everyday things and transform them into art. I like to shoot a series of images that relate to each other and then create a triptych. Pola-painting is another technique

that allows you to express your individuality. It can become quite addictive.

Image transfers. There are two steps involved in creating an image transfer. First, copy an existing image, from a slide or negative, onto Polaroid film; and second, transfer it from the Polaroid onto another surface – most commonly, fine art watercolor paper. In this section I'll explain the process for doing regular-sized image transfers (3¼" x 4¼"). More costly larger transfers are possible – 4" x 5", 5" x 7", 8" x 10" – but I suggest you attempt these only after you master the craft of producing small ones.

Here's what you will need:

1 Polaroid film: Polacolor ER 669 or the more contrasty Polacolor 100
2 a slide printer – Vivitar, Daylab Jr., or Daylab 11 – fitted with a Polaroid back, used for copying an image from a slide or negative onto Polaroid film
3 a tray with water at 100 degrees Fahrenheit (37.8°C)
4 a squeegee
5 a rubber roller at least 4 inches (10 cm) wide
6 a pair of scissors
7 watercolor paper: Hot-pressed, 140-pound, 100% rag watercolor paper works best. Buy the large sheets, fold them over, and tear into pieces large enough to accept the Polaroid with at least a one-inch border. This gives you a ragged, contoured edge.
8 a hair dryer (optional)

The first step is to copy an image to Polaroid film. Load the slide printer (they come with easy instructions) with the Polaroid film. Select your slide and place it in the printer. You will have to crop the image from the sides to fit it onto a Polaroid print. Expose the Polaroid film. Do not pull the film out of the slide printer yet. Soak a pre-cut piece of watercolor paper in warm water for a few minutes to make it more adherent. Once the paper is wet and limp, place it on a flat, hard surface and squeegee out the excess water. The paper is now ready to accept the image.

As you pull the Polaroid out of the slide printer, you spread the chemicals over the image. Wait ten to fifteen seconds before peeling the negative from the print, then place the negative face down on the paper. Use the roller to press the image down. Roll five or six times over the negative in the same direction, pressing firmly. If there are a lot of white spots on the image, you're not pressing hard enough; if the dark areas bleed all over the image, you're pressing too hard. After viewing the results, and with practice, you will gain a sense of how much pressure is needed to obtain the desired effect. Keep the transfer warm for two minutes by floating the paper (negative on top) in the tray with water at 100 degrees Fahrenheit (37.8°C) or using a hair dryer.

Place the paper with the negative on a flat surface and peel away the negative. Often, when you peel it back, small parts of the image come off. This is normal, a part of what makes image transfers unique. If you want less "lift-off," try peeling the negative away from the paper under water. If you want more "lift-off," don't keep the negative and paper warm after you use the roller.

Leave the finished transfer to air-dry. For cleaner whites and brighter colors, when your transfer is partly dry, soak it in a solution of one part white vinegar to four parts water for a minute or so, and then rinse it under running water for five minutes.

When the transfer is fully dry, you may want to add some color with oils or pencils. If the paper is curled, you can flatten it under a stack of books. A dry mounting press set at around 180 degrees Fahrenheit (82 °C) will also do the job.

You can duplicate the look of an image transfer on a computer, but I do not feel this is authentic. An image transfer is a piece of art and, as such, cannot be replicated.

Filters. There are several kinds of filters that aid in creating photo impressionism. You can soften an image to obtain a painterly effect. You can also transform what you're photographing by shooting through fabric, such as lace or nylon stockings.

Tiffen and Hoya are two companies that offer a wide array of softening filters. Tiffen has the Soft FX in grades from one to five and the Softnet series (a piece of nylon fabric inside the glass) in grades two and four, and in black or white. White softens the images and makes the highlights glow, while black only softens the image. Hoya has a diffuser as well as a softener in grades A and B. (Hoya grades the amount of softness using letters.)

You can create your own soft-focus filters. Evenly apply a light coat of aerosol hairspray to the surface of a UV or skylight filter by holding the aerosol can 20 inches (50 cm) from the filter and spraying lightly until the desired diffusion is achieved. If you find it difficult to see and to focus, there is too much hairspray; wipe it off and try again. An 81A filter can be used if you prefer a warmer image.

If you want to create other softening effects, try photographing through nylon stockings. The nylon's tinge will affect the color in the photographs, and the amount of stretching will vary the degree of diffusion.

In addition to soft focus there are many other filters you can use in your photography. I recommend a polarizing filter, which also comes in a warm version, for photographing outdoors. This enables you to reduce glare, thus producing more saturated colors. It also helps to eliminate or reduce unwanted reflections and will intensify a blue sky. I like the warm version, which is a polarizing and warm 812 (similar to 81A) combination.

Color-correcting filters allow you to remove unwanted color casts in your photographs. Warming filters (81A, B, or C) are very effective in portraiture, giving skin tones an appealing hue. These filters also balance the coolness in winter scenes, especially in snow, which turns blue in areas of shadow. Although less frequently needed, cooling filters (82A, B, and C) reduce excessive warmth in some instances and put blue back into your pictures. This is especially useful if you are photographing purple and blue flowers.

Other filters, such as enhancing or color-polarizing filters, are great at punching up colors, but you have to be careful not to lose the naturalness in your photographs. A picture can have great color but look fake. The viewer should not be aware that a filter has been used.

These tools, techniques, and suggestions will not produce effective impressions in and of themselves. They need creative minds and human emotions behind them. Experiment, test, reject, and practice. Above all, feel the results. **AG**

These two photographs were shot eighteen years ago. They capture a spontaneity that cannot be planned. I showed these images to a company that puts out fine art posters and they decided to publish them as a pair, *Crème Glacée I* and *II*. Hand coloring was popular at the time, so they added some color to the black-and-white images. The posters have done very well over the years, going through three reprints. I think the success is due to the timelessness of the photographs and the spirit of childhood that they convey.

I photographed a series of black-and-white images of Paris with the intention of hand coloring them. This row of windows in the Marais district caught my eye, and I instantly visualized how I would add hues to the shutters to make them stand out against the brickwork. I printed the photograph on Ilford Gallery matte paper and added the color using crayons.

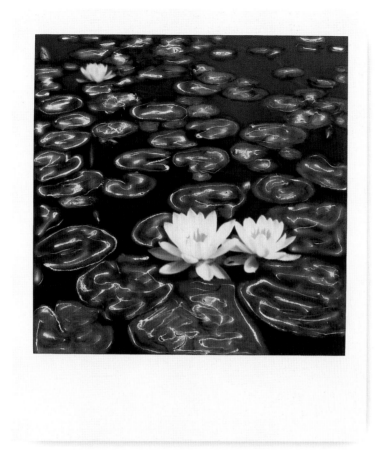

Polaroid sx-70 is an instant film that allows manipulation of the image as it appears before your eyes. The scratches on the water-lily pads were drawn in the first few minutes of the print's development. As the emulsion hardened, the effects of scratching and pushing the image around became more subtle. You can alter either the whole image or just parts of it. My preference is to leave small details untouched, like the flower blooms in this photograph.

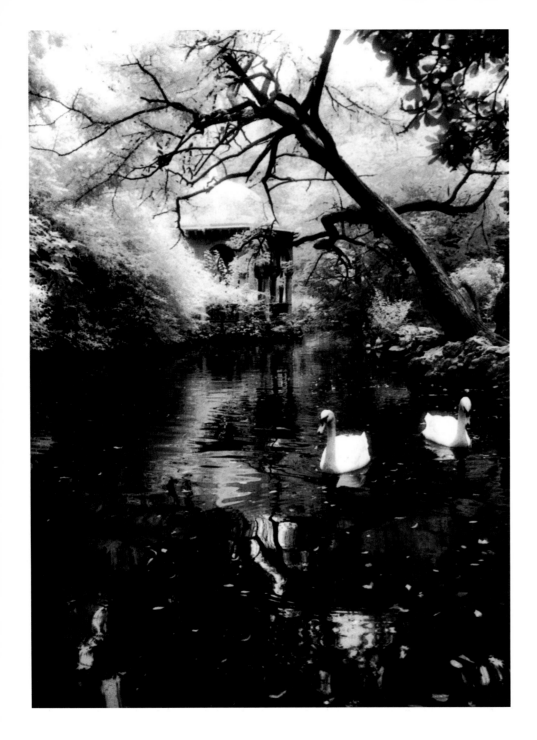

On my very first photography assignment I was commissioned to produce images for an article on Spanish gardens in a travel magazine. Quite nervous, I traveled to select gardens from Barcelona to Seville, capturing many images in the hopes that one of them would grace the cover of *Destinations*. I decided to experiment with Kodak black-and-white infrared film, which is extremely sensitive to radiation emitted by foliage. If successful, I knew the images would be very surreal and display the gardens' enchanting character. Although it was not used in the article, this photograph of swans made quite an impression on the art director of the magazine, and I was soon assigned to photograph the countryside of Portugal.

I took photography a step further by hand coloring this image of the swans. I added color to the Ilford Gallery matte paper using Marshall oils. I started with the larger areas, working from top to bottom, and then did the detailing with toothpicks and cotton swabs. As the oils take some time to dry, you can fine-tune the colors to your satisfaction over several days. I feel the hand coloring of the image allowed me a greater degree of self-expression.

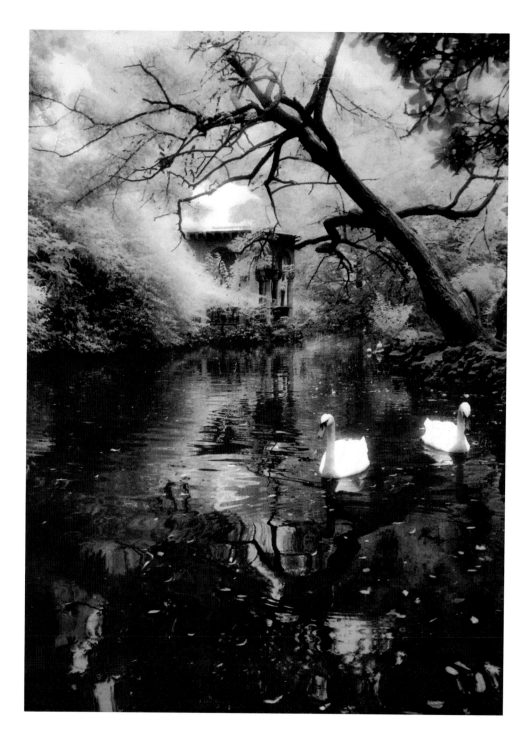

One of the things I love about Polaroid transfers is that you can breathe new life into some of your favorite, perhaps older, images. With the use of a Vivitar slide printer I transferred this photograph from an older slide onto Polaroid 669 film, and then onto a piece of watercolor paper. I love the effects of the transfer, like the borders, some of the image lift-off, and, most of all, the miniature size of the final product.

One hot afternoon on assignment in the Caribbean, I decided to photograph in the shade. The hotel where I was staying was painted in beautiful shades of blue and pink. I moved the chair and table around on my balcony, and then added the hibiscus to the scene, making sure the color of the flowers would complement the beautiful pastel hues in this still life. A soft-focus filter added a dreamy quality.

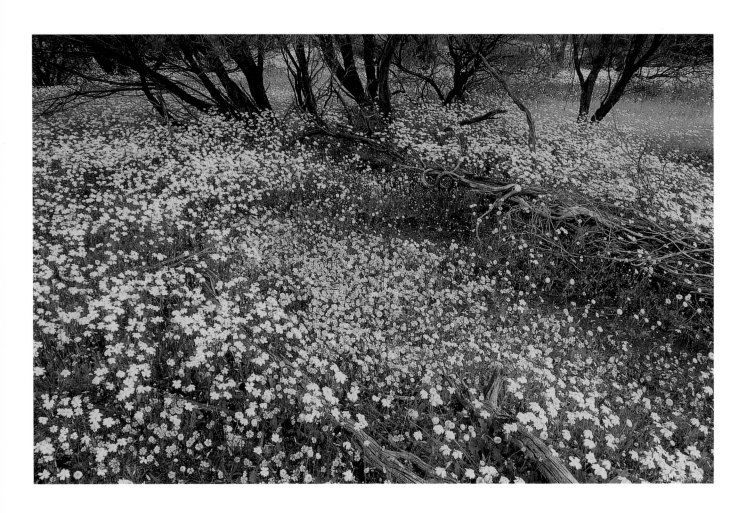

THE SUBJECTIVE IMAGE
AN INTRODUCTION

The privilege of a lifetime is being who you are.

JOSEPH CAMPBELL

In this section of the book we will talk about ways, other than impressionism, in which you can reveal yourself in the pictures you make, including both *what* you choose to photograph and *how* you choose to photograph it. Perhaps the most effective way to illustrate our points is by drawing from our own work ideas, examples, and suggestions that might be relevant to yours.

Everything you do reveals something about yourself. Even when you try to disguise what you're doing, the very act of hiding says something. So, up to a point, every individual is an open book. And we communicate who we are especially by what we say and what we do.

What photographers do is make pictures. These pictures reveal what interests them, how much it interests them, in what ways it interests them, and how and when their interests change or develop. The pictures form part of the photographer's life story, and they are one way of telling it. For these reasons some people are actually afraid of showing their pictures to others.

Perhaps you can imagine the range of emotions we experienced as we selected images for this book. Despite the fact that our primary goal was to be as helpful to you as possible, we knew that with every picture we chose, we were saying, "Here I am."

We hope that this section of the book will encourage you to explore your own responses to the subject matter you choose, and also to contemplate the ways in which you photograph it. In some chapters we will provide specific guidance and practical suggestions for photographers; in others, such as "The intimate Earthscape," we will examine some of the interactions of the creative process, in the belief that this is every bit as important as "hard instruction" or discussion of specific techniques. We believe that all photographic tools and techniques are intended to serve the photographer, not the other way around.

page 90: I came upon this spread of wildflowers in bush country at the edge of Western Australia's outback. While there were flowers everywhere that spring, in this natural composition the blues anchored the foreground while the yellows led to the beyond – the one rooting me, the other luring me on to undiscovered places.

above: Earth is my Mother. She carried me in her womb. She gave me birth. She cradled me. And then she let me go.

Landscape is the firstborn of creation. It was here hundreds of millions of years before the flowers, the animals, or the people appeared... In the human face, the anonymity of the universe becomes intimate... The hidden, secret warmth of creation comes to expression here.

JOHN O'DONOHUE, "ANAM CARA: A BOOK OF CELTIC WISDOM"

"Intimacy" means emotional closeness, but the word implies physical closeness as well. It is difficult to be intimate with somebody with whom you have never shared physical space. Human intimacy can be warm, affectionate, and caring. Some physically intimate relationships can also be exceedingly destructive.

What do I mean by calling this chapter "The intimate Earthscape"? In his book *A Haunting Reverence*, Kent Nerburn speaks for me:

We are as children on this land, a shadow on the still life of time... We are still explorers and discoverers, seeking meaning through movement and examination. But we are coming to a time of listening... Voices rise up, and we begin to hear the echoes in the stones.

I come before you to speak of these echoes. I do so with humility and trepidation, for these are things not easily expressed. They live on the far margin of the spirit, where one hears the voice of winter on the autumn wind, or the chant of remembered lives rising from a plot of barren ground.

We have all heard this voice. It comes, like a phantom, in the play of sunfall on a summer hillside, or in the haunted still before a storm, or in some moment so fleeting and ineffable that we cannot catch it as it passes, but find it lodged deep within our spirit, where it dances with the colors of a dream.

I have heard this voice for years now... [but] now I hear it clearly. It is the voice of the land, as powerful as a shadow, as haunting as the moon.

While some animals do interact emotionally with people, most do not, especially insects. Plants seem less likely to have feelings for us. Soil, air, and water are probably not conscious, and consciousness, particularly consciousness of self, is essential to intimacy. So, how can we reasonably use the phrase "the intimate landscape"? How can we speak of loving the sea, forests, or deserts when they cannot return that love? For me it does not matter that this love is unrequited. For me it is enough that they are there. Like Nerburn, there is something lodged deep within *my* spirit, something

beyond ordinary time and space, that is profoundly rooted in the current presence of specific natural phenomena and situations, something that dances with the colors of *my* dream.

What I'm talking about is our phylogeny, especially our need to stay connected to our evolutionary history as we live in the present. In one wonderful *Charlie Brown* strip, Snoopy set off to visit the puppy farm where he had been born and raised. The final frame shows him on his back, his front legs raised in horror and rage, as he shouts, "They've paved over my memories." The willful destruction of what we knew and loved as children, especially natural places, causes us anger, sorrow, and grief. When we rip out meadows and streams to build parking lots and shopping malls, when we disregard our long past with its enormous psychic legacy, it may be good for business, but it is incredibly destructive to our souls. The people who participate in my workshops (with André in Canada and Colla Swart in South Africa) often have a profound desire, almost an urgency, to reconnect with the natural realm. Nothing could be more natural than this desire, which is rooted in our long development as a species.

Achieving this connectedness, like coming to love another person, depends on familiarity with the object of desire. You can't love what you don't know, or places that you've never been, or things you've never experienced. I've traveled on all of Earth's continents, and wherever I go, sooner or later somebody native to the area extols the special virtues and beauty of that place. People who live on the world's great plains, prairies, or steppes, like those who live in the shade of the Andes or the foothills of the Rockies, all speak of the grandeur of their particular place. My mother's several sisters were convinced that no place on Earth could be more beautiful than New Brunswick's lower Saint John River valley. My mother herself spoke of the rustle of dry grasses in ditches and fields, and drew my attention to flocks of birds flashing black to silver as they soared and changed direction in the wind. Although she had grown to adulthood in the city, my mother was sensuously connected to Earth, and she was especially sensitive to smaller things. I always felt her emotional closeness to them – her intimacy – and I realize that it was she, more than anybody else, who led my sister and me to experience connectedness with them as well.

So, when I speak of the intimate landscape or, more accurately, the intimate Earthscape, I'm talking about smaller spaces, spaces that I can know both physically and emotionally, little places that matter to me, places that may function easily as metaphors or symbols of certain aspects of my emotional life: a protective glen of old cedars in the forest near my house, a small canyon of shimmering granite in Namaqualand, the dark, mossy rocks of a tiny waterfall decorated in autumn with ten thousand gold and crimson maple leaves, a bank of sand in the lee of a fallen tree, the tapestry of brown grasses behind my house. These are all relatively small habitats, but they are home for an amazing variety of living things, and they function as communities in which everything is interdependent. The soil (rocks, sand, humus) in these interdependent communities arrests my eyes, and sometimes its richly pungent odor mixes with the aroma of rotting leaves or with the delicate fragrances of flowering plants. Water flows around rocks or lies calmly in small ponds, perhaps in the form of ice, or rises as mist from a river marsh. And these physical, sensuous specifics evoke a creation far, far

beyond themselves, something beyond understanding, something that calls from "the far margin of the spirit." It is a primal voice.

Sometimes I endeavor to photograph the entire spot, trying to get a descriptive overview at a particular time, but most of the time I select a small part of it, or specific objects whose presence and appearance draw me to them. Sometimes I make documentary images, but often I employ interpretive or impressionistic techniques when a literal rendering seems insufficient to express what I'm feeling. In either case my approach is always a very personal one. When some part of the natural world functions as a symbol, or as a metaphor, or as a vehicle for my emotional life and, in the deeper sense, my spiritual life, I endeavor to show it in the images I make. And I am often conscious of my deeply held belief that every photograph is the description of a meeting between the subject matter and the photographer, and that the role of the one is not necessarily more significant than that of the other.

So, how can you photograph an Earthscape intimately? By coming to know it. It's not that you have to be familiar with a particular rocky shoreline or a marsh before you begin, but rather that you have to go with your eyes and heart wide open. You have to see it in the beauty or ugliness of its physicality, overall and in intricate detail. You have to observe its design, because that reveals both its history and how it is functioning in the present. You have to see how it has been hurt and suffered, even if you choose not to photograph its wounds. In short, you go expecting to make contact.

You will always bring to your image-making your personal life experiences. Two photographers I know are repulsed by patches of red, orange, and yellow on otherwise green autumn leaves. Both of them work with burn victims and/or skin diseases. You may also bring to the land something in yourself that is at once powerful yet unexplained. For example, although I grew up in an area where water is plentiful and growth can be lush, I am deeply haunted by deserts, especially rocky ones. One day when I was hiking in a mountain desert in the northwest corner of South Africa, far from human artifacts or sounds of any kind, I had the experience of sensing – correctly – what I would find when I walked around the next gigantic boulder. With this experience came the feeling of having been or having lived here before, neither of which was the case, at least in my limited awareness. Something was occurring here that I did not understand but which, in my liberation from all contemporary artifacts, I speculate to be a "returning" to or clear psychic association with the world from which I have come. When I'm photographing in a desert, I'm always very aware that I'm dealing with something primal in myself that the desert evokes or symbolizes.

You will also bring your personal sense of design to natural scenes, which may or may not conflict with the situation you want to photograph. To impose a human sense of order on a tangle of grasses or a bit of the forest floor may well show a lack of understanding and respect for the nature or state of your subject matter, something American photographer Eliot Porter was never guilty of. Porter's semi-close-ups always seemed to reveal the apparent randomness of nature. The twigs and leaves were not neatly arranged for the camera but told of a breeze that might have dropped them in a thousand different places. An overly organized composition would have deprived viewers of the sense of that breeze. To

take other examples, a field of wildflowers is worthwhile in its own right; it does not need a child standing stiffly, or romping for that matter, in the middle of it — not, that is, if you want to keep the emphasis on the field. In my view, if the field you are photographing has no apparent center of interest, you should be careful about introducing one for reasons alien to the situation. Similarly, the person in the stereotypical red canoe strategically located in a stereotypical one-third position may draw attention away from the wilderness and put it squarely on the human being. Fields and forests and deserts do not derive their value either from a human presence or from the imposition of human design. There's nothing wrong with using these things, if that's what you want, but the message of your image will not come from nature. Good design of your photographs, especially images of natural situations, always involves responding sympathetically to both the content and the design of the subject matter.

Does this contradict an impressionistic approach? Only in the most literal sense. Certainly, in impressionistic images you will deform or distort literal reality, but when you are sensitive to the essential or underlying structure of the material, you will never regard superficial truth as the whole truth, and you will endeavor to use techniques that help you reveal a more complete picture. Nevertheless, there may be times when you want to treat the material like visual clay, when you want to abandon literal reality in order to create or evoke in others a feeling or emotional response that matters deeply to you. The truth you are expressing in such cases is one of spirit, and your expression is made possible *because* of nature, not despite it.

Thomas Moore, a leading lecturer and writer on archetypal psychology, mythology, and the imagination, expresses the best sort of interaction between humans and nature when he writes in *Original Self*:

We are nature, and to be profoundly in synch with the seasons and the weather is an effective way to be in tune with our deeper selves. Obeying the sun, regarding the moon, imitating the plants, moving with the winds, we find that elusive sense of self that we thought was only interior and not part of the world. **FP**

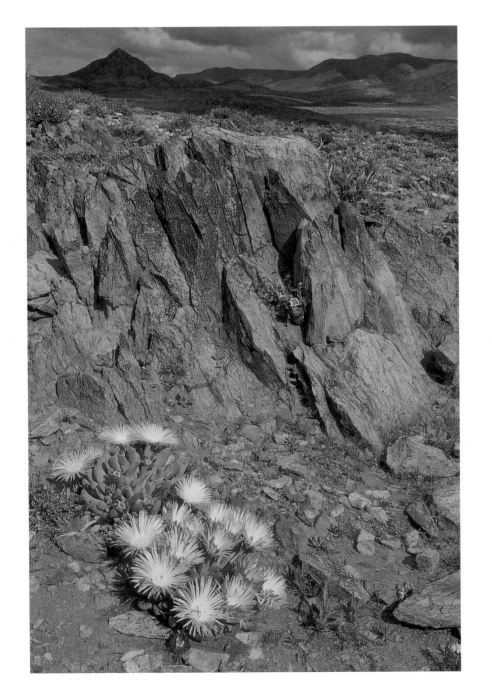

For me, the little clump of flowers huddled in a vast, forbidding landscape symbolizes a common perception of the human situation. As we concentrate increasingly in cities and suburbs, removing ourselves to an unparalleled degree from natural things, we become insensitive to them and afraid of them. A person close to nature will realize that the rocks are protecting the plants from strong winds and storing the sun's heat to warm the night air. He or she will see the "ominous" clouds as forecasting life-sustaining rain. And such a person will feel Earth's intimacy.

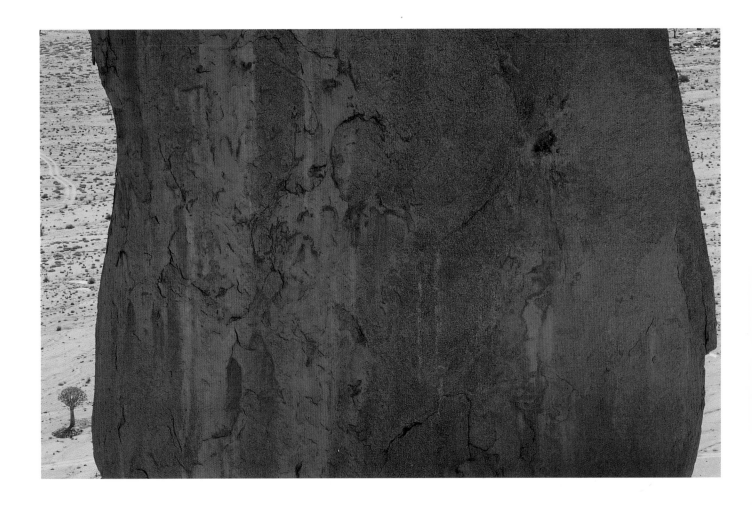

An enormous boulder, perhaps thirty stories tall, balancing on other boulders, towers over the desert below. Like a god, it seems eternal; but its surface reveals that, like a human being, it is aging. As with many natural objects we see ourselves in it and yet apart from it; there is both intimacy and distance, the two essential components of a good relationship. Hiking here, far from every human sound and artifact, I lost my sense of the linear, historical movement of time. There was only now.

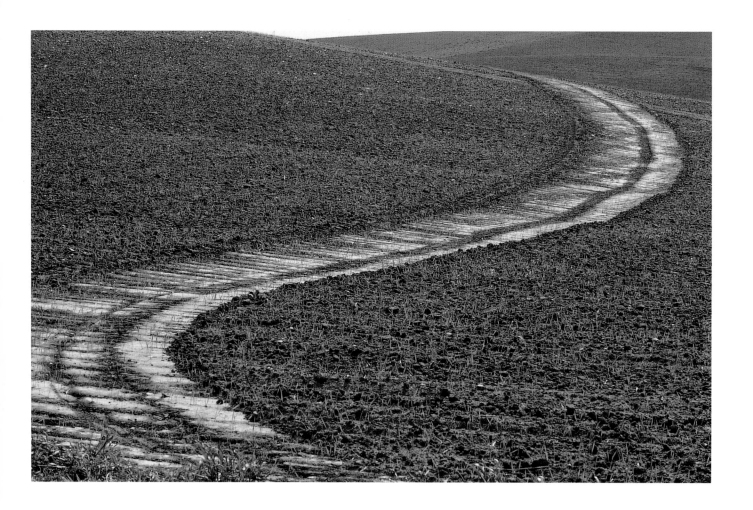

The human trail leads across dark soil toward a tiny area of light. Both the subject matter and my composition are symbolic, together expressing the fundamental spiritual search that engages every person, even those who cannot admit it to themselves.

The seasons circle. The new year emerges out of the old. The feeling in the air – in the lakes, the woods, the fields, and the soil itself – is that everything good is possible. Birds are mating, water is warming, insects and tadpoles are hatching, grasses are sprouting. I want to live forever!

The seasons circle. Winter seizes autumn, holding it longer and tighter with each successive grip, until there is no release. These two images show the process in quite different situations that arouse distinctly different feelings. In this picture, life (represented by the root) seems to have gone to sleep, and the snow is coming to cover the sleeping form and keep it alive. In the facing photograph the ice has caught the branch (also representing life) and is refusing to release it. Beautiful though this little scene may be, it suggests captivity and death.

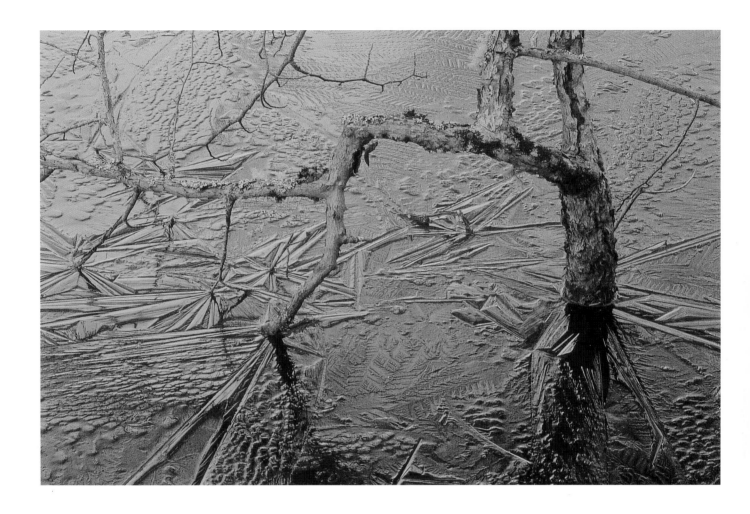

A major visual difference between these two images is the tonal contrast. There are abrupt changes from white to a much darker tone, or to black, throughout much of the facing picture, whereas here the transitions tend to be very gradual.

Notice, however, that there are tiny highlights in this photograph as well as areas of pure black, so the actual range is the same in both situations.

Photographing close to home

It's good to see you! Tell me, are you home or away?

AN ELDERLY NEIGHBOR WHO MET ME PHOTOGRAPHING
ON THE ROAD NEAR MY HOME

I've driven and walked the country road on which I live thousands of times in the last thirty years. It became so familiar that, to a considerable degree, I stopped observing it. We tend to do that with familiar things and places. We "label" them as a stand of bushes, or a driveway, or a dining-room table, and we stop looking at them. As a result, we often see least well around home.

Although most country dwellers, like me, tend to love the place where we live, to regard it as beautiful (sometimes a neat way of justifying why we live there), we are often quite oblivious to it sensuously. And we long for change. Tibet may seem an exotic place to visit if you live in Winnipeg, Winnipeg if you live in Cape Town, Cape Town if you live in Dubuque. A remote farm may be wonderful if you live in downtown Montreal, but the farm dwellers may be itching for a trip to "the big city." The fact is that every place is local to somebody, and every place is potentially exotic — the farther away, the more exotic, it often seems.

Just about everybody carries along a camera when visiting exotic places, and they make pictures. They think there will be exciting things to see and, more often than not, this expectation helps them to see them — up to a point. But they would see so much more if they had practiced being observant back at home.

Today is nearly the last day of November, and also the last day of a month-long personal assignment. Every day for thirty to forty-five minutes, come sun or cloud, rain or snow or high wind, I've been photographing along a short section of the Shamper's Bluff Road that is very familiar to me. The section is about an average city block long, with tangled bushes and grasses on both sides, but no buildings. I set only one condition for myself: never leave the dirt road. I could not cross the ditch on either side.

Most days the sky has been heavily overcast, an unusually long spell of such weather that has set records. Because of the weather and the time of year, the range of colors was very restricted. However, I like secondary hues — browns, beiges, faint oranges, straw colors, and off-grays mixed with blacks and near whites — which is exactly what I got. In a couple of places there were a

few bright crimson cranberries still hanging on high bushes. Nevertheless, after five or six days I was pushing myself visually and technically, which of course was the whole point of the assignment.

I've now seen all the photographs, and I'm pleased. Not pleased with what I accomplished every day, but certainly with the work of many days, with what I achieved overall. Now I'm editing the pictures and choosing two from each day to assemble as a sixty-slide show. From the images I made on the day it snowed – snow outlining every twig of every tree and bush, every blade of grass – I can choose only two, even though I wish I could show about twenty. Tough editing is part of my assignment as well.

Photographing around home has a lot of advantages. It's relatively cheap, with no travel or accommodation costs, and there are no language barriers. You can set aside a specific period of time – an hour every other day, for example – but you must keep this time as faithfully as you would a doctor's appointment, and make sure your friends and family know that! You can easily return to any subject or location again and again: your garden, your grandmother, your daughter's motorcycle, the jackets hanging in your porch, patterns of yellow egg yolk left on your breakfast plate, the local hockey rink, the woods behind your house. You also have time for conceptual assignments: delicacy (perhaps finding or creating pale, subtle hues), your dark side (deliberately searching out objects that symbolize aspects of your personality or character that you dislike), formality, pressure, grace. Or you can de-label common objects by approaching them in a new way. For instance, try photographing a canoe or truck without ever revealing what it is. Make pictures of the spaces between things.

Toss a colorful blouse into a pond or swimming pool, and either photograph it in a non-representational way or try to convey the impression of drowning. Treat an old pair of jeans like a flag – physically and symbolically – or get sexy with them. Using three or four stuffed animals, make up a photo story for your younger grandchildren. (I've seen and listened to some great ones!) And while you're at it, assemble a short slide show of colorful abstracts – nothing recognizable – for preschoolers. They'll go mad about it, especially if you accompany it with some lively music.

Your assignments, like my assignment, will keep you in shape visually and "in touch with" your equipment. While your primary goal will be to make some satisfying images, the more you work with a variety of lenses, or with differing lens openings at varying distances, the more likely you will be to develop an acute sense of what is possible. Set a potted plant on the railing of your deck, then photograph it with a 20mm, 35mm, 85mm, 135mm, and 300mm lens, or with a zoom lens that covers as many of these focal lengths as possible. Use a lens or focal length that you normally would never choose, perhaps a 20mm lens in the case of the potted plant. Also experiment with techniques that you may seldom employ, such as multiple exposure or shooting for montage. One day I carried a large, broad pot containing reddish-orange geraniums into a field of dandelions, and made a whole series of multiple-exposure images in which I both zoomed and rotated the lens from one exposure to the next. None of the images was a failure, and several of them excited me with their colorful swirls.

The truth is, most people will learn to photograph at home if at all. Either they will learn to see, and to use

their equipment well, where they live and work, or they won't do it at all. A week-long workshop, a series of evening lectures, a day-long photographic seminar can be very helpful, but you learn how to photograph well the same way you learn to drive well: by doing it carefully and frequently. Learning to see subject matter well, learning to design image space well, and learning to use your tools effectively takes discipline – and discipline is something you rarely develop on a trip. You acquire it before you go, and then you take it with you.

You should not regard photographing around home only, or even primarily, as a training session, however. If you consider your home (or general area) as the place where you engage in most of your serious artistic endeavors, you will bring to your efforts a degree of insight and maturity almost right away. The reason is simple enough: when you take your art seriously, you're taking yourself seriously too. **FP**

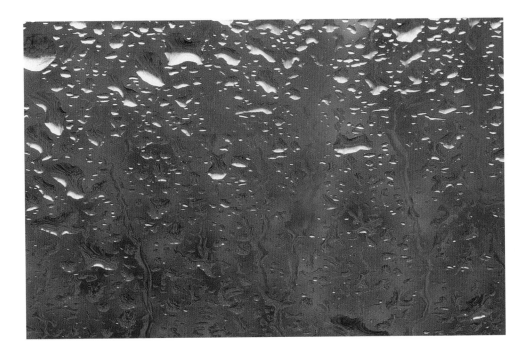

Both of these photographs, and the next two, were made as part of a thirty-day (November) assignment along a short stretch of road near my home. There came a day when an icy deluge of rain and sleet was whipped to a frenzy by high winds. Dreading to open the car door, I sat staring at some roadside color through water drops on the opposite window. Focusing and re-focusing my 100mm macro lens, I made the picture you see here. However, before I could make a second composition, my breath had fogged every window in the car and I was forced outside to make at least three more photographs.

bottom: In a way, this situation was similar to the one illustrated above. Although the morning was sunny and cold, I soon realized that I had not dressed warmly enough and I retreated to the lee side of my truck, where melting frost on the black hood quickly captured my attention. Using my 100mm macro lens at the widest aperture, I aimed downward slightly into brilliant reflected light and experimented with over- and underexposure. Later, combining some of the lighter exposures in a variety of ways, I intensified the weak golden brown hue.

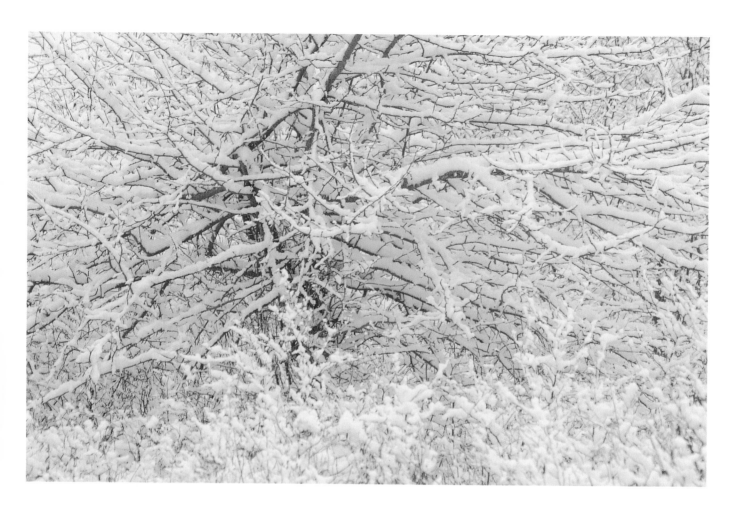

After weeks of dark, overcast skies, wet snow transformed the roadsides overnight. All the shades of brown disappeared, a few highbush cranberries providing the only color (see facing page). By shooting every day I became so familiar with every shrub and clump of grass that I knew exactly where to look first.

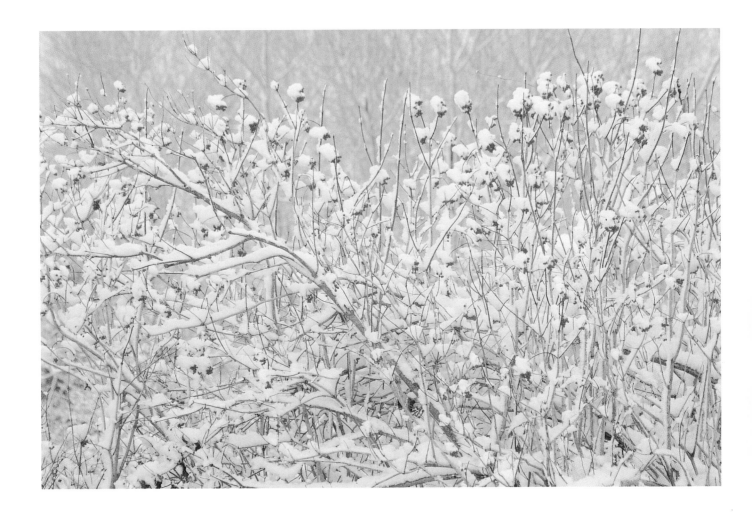

For this picture and the one opposite, once I had selected a lens opening to achieve the depth of field I wanted, I over-exposed by one and a half shutter speeds, or even two shutter speeds, to make certain I had pure white in the snow. This snow was welcome, but if I had felt differently (maybe if I had been shooting in April), I might have overexposed less. How a person feels about snow at any given time is often very circumstantial.

Although I have visited all the continents, some repeatedly, I make more than half of my photographs right around home. My camera is rarely off the tripod. One day after I had washed and dried every pair of jeans I own, I laid them on top of one another on the broad seat of my deck as I removed them from a clothesline. Because I have come to be constantly alert to the design of things, the thin black lines separating the various tonal gradations and saturations of blue into narrow bands were sufficient motivation for me to make pictures.

THE SUBJECTIVE IMAGE

A few months later, very near the spot where I had photo-graphed my jeans, I trained a lens on this pattern of car tracks in wet snow. As with the jeans, dozens of compositions were possible. I chose various points of view, used a range of lenses and lens openings, and employed techniques such as panning, blurring, multiple exposure, and montaging. Such exploration is always worthwhile, although in this case I preferred the simple design you see here.

My barn has been photographed thousands of times by myself and others, but only one other person has also captured this window when the interior of the barn was lighted by the sun's last rays shining through another window. For me, the picture provides the perfect example of why it's important to go back repeatedly to familiar objects and places. Never assume that you have seen it all.

In the window on the opposite page you'll notice several panes of pebbled or textured glass, and also a stack of colored covers for some small pails. One day about noon I went back to the barn and used my camera and 100mm macro lens to look through a textured pane at the colorful mix. Then, somewhat overwhelmed by the jumble of hues, I gradually raised the camera until I had only a narrow purple band forming a base for the much larger area of almost black-and-white wedges.

Near my South African home is a small car graveyard. One day, risking life and limb, I climbed into the place where a front seat used to be and shot through the front window, long since shattered but still intact. I was careful to include the bit of black at the bottom and to observe the placement of the highlights. Of course, where I made the image and what it was that I photographed are essentially irrelevant details. This is simply another example of how you, like Alice, can transport yourself into Wonderland without ever leaving home.

This is the same sheet of foil you saw on page 45, but the surrounding objects have changed. The yellow tumbler has been removed. Both sunlight and colors from the walls are now causing the reflections. At the time I made this composition, it reminded me of the first space-age film I ever saw, *2001*.

You don't need to go anywhere to go everywhere. Try photographing in and around your kitchen sink, your laundry basket, the chair you're sitting on – everywhere around home. I can think of no situation – none whatever – where exciting visual possibilities do not exist.

Photographing your travels

. . . the sight of stars always sets me dreaming just as naively as those black dots on a map set me dreaming of towns and villages.

VINCENT VAN GOGH, QUOTED IN "THE WORLD OF VAN GOGH" BY ROBERT WALLACE

Travel photography is my passion. It was a gradual seduction. First I was challenged to capture the spirit of a place; later I was tantalized by the ochers of a Saharan desert; and finally I was consumed by the gold bell towers of Mexico. Now some of my greatest pleasures come from discovering a foreign country, experiencing a new culture, trying new foods, hearing new sounds in language and music, and, most of all, connecting with the people of a land that is not my own.

When you are planning a trip abroad, even the research on your destination is exciting. Looking at photographic books on the place you will be visiting may inspire you and help you decide how you want to photograph it. It is at this stage that I decide which film I'm going to use and which lenses I will take with me. Once, a photograph I saw of the Eiffel Tower in black-and-white made such an impression upon me that I took only black-and-white film on a subsequent trip to Paris.

Preparing for your trip. A good travel agent can help you with many details: do you need a visa to enter the country? immunization? malaria pills? A good guidebook is well worth the investment. Travel magazines such as *National Geographic Traveler*, *Condé Nast Traveler*, and *Travel & Leisure* offer a wealth of information. The Internet will usually provide most of the information you need to organize your trip. One useful site is www.tripprep.com, which will inform you about passport and visa requirements to enter most countries, and about immunization and any current health risks. An Internet search can also tell you the history of your destination and the sights to see when you arrive. Another important part of preparation is to book flights and car rentals well in advance, to ensure availability and to take advantage of any early-booking discounts. I make a point of learning the phrase "Can I take your picture?" in the native language of any country I visit. Be prepared!

Theft is a major problem worldwide, and photographers are prime targets. It's imperative to insure your gear before you set off on a trip.

Packing and choosing what to take. Make a list of the items you'll need. Photographers tend to have a lot of equipment. You don't want to forget a useful item while toting unessential gadgets. Here is a list of what I usually take:

Camera bag and photo vest. I like having both, but I travel with my gear in the camera bag. Then I use a cloth vest – lightweight and comfortable – on outings, with a selection of lenses, plenty of film, a spare battery, lens cleaning tissue, and two filters. All these items are thus quickly accessible.

Camera equipment. It's a good idea to bring two camera bodies, with spare batteries, and lenses that offer you a broad shooting range. Zoom lenses from 24mm to 300mm will allow you to shoot wide land-scapes, distant scenes, portraits, and details. What you take depends on what you want to shoot. Some people will need a macro lens, others will require a 500mm lens. On an expedition to Greenland I photographed massive icebergs floating in the sea and found myself using wide-angle lenses and medium-telephoto lenses much more than long-range lenses. On a trip to Namibia, however, I wished I owned a 500mm lens to shoot close-up portraits of cheetahs and leopards. You might aim to travel light, sacrificing a lens or two. Do not let too much gear weigh you down. Take the filters you like. I recommend two: a polarizing filter and an 81A warming filter. Tiffen makes a combined warm/polarizing filter that is well worth the investment.

Film. Always take enough film. Film tends to be more expensive in other countries, and you won't always be able to find your film of choice. If you travel by air, the film should be in your carry-on luggage. The x-ray machines used for checked luggage are very powerful and this is where your film could be ruined. Whenever possible, ask for hand inspection. It's a good idea to put your film in clear plastic canisters, and then put the canisters into clear plastic zip-lock bags. This makes it easy for the security officers to hand inspect. If your film is in black canisters, you might have to open each one for inspection, and neither you nor the security agent will be impressed. It is usually safe to put film through the x-ray machines for carry-on luggage, which are less powerful, but avoid it if you can. You will be hard pressed to get your film hand-inspected in Europe, but it does not hurt to ask.

Tripod. A tripod makes for better photographs because it allows you to compose with more precision. It eliminates camera shake and enables you to use a slower shutter speed than you could if you hand-held the camera, affording you greater depth of field. I use a Manfrotto base #055 with a quick-release grip #222. I pack the two pieces separately in my checked baggage. That way, I'm not lugging them through airports, and I don't exceed my carry-on limit.

Arriving at your destination. On arrival, you may need to rest before setting out with your camera, but if you're too excited and bursting with energy, by all means go and make photographs. A good first stop is a bookstore, to browse through local photo books. Even looking at postcards can inspire you, or at least show you the "photogenic" spots. Try to get acquainted with the place you intend to photograph. Figure out where the sun will be positioned when it rises and sets. Often what is poorly lit in the evening will be appropriately illuminated in the morning.

Making travel photographs. Photograph at all times of the day and night. At night, with your camera on a tripod and using a cable release (you can use the self-timer if your camera has one), try to capture the artificial lights against the fading colors of the darkening sky. This is a good time to "bracket" your exposure, because metering the level of light is tricky at twilight. Keep shooting even in stormy weather, when some of the most evocative images can be made. Make notes on your journey to facilitate captioning your photos when you return home. If your photos might be published, get a model release from the people appearing in them. I always carry releases in my camera bag, photo vest, and wallet. It's good to have a witness when the person is signing the release. If you promise someone you will send them a copy of a picture, do so.

A friend asked me once to look at some pictures he had taken on a trip abroad. Although the images were stunning, I had to wonder if anyone lived in that place; no people appeared in the photographs. Successful travel photography contains a variety of subject matter and, most importantly, a human element – a close-up portrait of a face with character, or a crowd on a popular street.

Look for details. The bright fabric of a sarong, the rugged hands of a plantation worker, a symbolic tattoo – each illustrates its own story. In Morocco, I took a photograph of a woman's hand covered in henna, the temporary paint ritually applied by older women to the hands and faces of younger ones for celebrations. This simple image portrayed the culture, tradition, and ritual of the country.

My fondest travel memories are of the people I've photographed: the three women working in the fields of Portugal who shared wine with me; a carpet merchant in Morocco named Brahim who invited me to his wedding; the Turk who waved to me after I photographed him in the distance having tea on his boat; the three men who bought me rounds of ouzo in a Greek taverna. The camera gave me a glimpse into these people's lives, and I ended up with considerably more than a photograph.

On assignment for Air Canada, I photographed a story on the south of Morocco. Up before dawn in the small town of Tinerhir, I discovered that people would have to climb this hill to reach the center of town. With an 80-200mm zoom lens on my camera, I framed the crest of the hill with part of the town and the surrounding mountains as a backdrop, and waited for the sun to rise and people to come by. When this older man appeared, oblivious to my presence, I instantly shot a few frames. This image made the cover of the magazine, and it remains one of my all-time favorites.

Morocco

The view of the snow-capped Atlas Mountains is quite spectacular. As the plane nears Marrakesh, my heart is racing. I have read my Morocco guide-book on the flight and this has heightened my anticipation. The plane touches the ground at last. After clearing customs with my small suitcase, heavy camera bag, and tripod, I am bound for the old part of Marrakesh. Le petit taxi drops me off near the main square, Place Jemaa el Fna, and from there I look for a room close to all the activity. It's mid-morning and already I feel the heat. I sit down at a café and order mint tea – or perhaps I should call it sugar with mint leaves! I need a moment to calm down and take in the sights and sounds. Watching veiled women, and men wearing turbans and the long, hooded tunics called djellabas, I feel an overwhelming desire to start photographing. With a camera around my neck and carrying a few extra rolls of film, I set off on a scouting trip.

A few hours later I have figured out where to be for the best or "magic" light – the hour before sunset and the hour after sunrise – and I rest.

Now it is time to go. I wear my photographer's vest, with a 28-70mm lens in one pocket and plenty of film in another, and carry my camera fitted with an 80-200mm lens on the tripod. It is customary to give a few coins to the performers who pose at the Place Jemaa el Fna, so I make sure I have lots of coins and small bills. The sun is getting low, casting long shadows and giving off a nice warm hue. The square is coming alive. Snake charmers, storytellers, acrobats, and musicians vie for a paying audience.

I try a few panning shots to emphasize motion and to abstract the background. (The photo on page 124 of the man on a bicycle was shot at $\frac{1}{15}$ second.) As the sun's rays get more diffused by dust particles and haze, soft, warm light allows me to take better portraits of some of the performers. Once the sun sets, with my camera on the tripod, I shoot both details – close-ups of ceramics, carpets, windows – and silhouettes. These will add depth to my travelogue. I'm looking forward to what tomorrow will bring.

Up before dawn, the four-thirty call to prayer having startled me and reminded me where I am, I set off to look for exotic scenery. I'm rewarded with a beautiful sunrise casting orange hues on the ocher-colored ramparts. The city is awakening. Using my long lens, I capture people going to work, men on carts pulled by donkeys, and women peering through colorful veils. Most of them are unaware of my presence or intent. I take candid photos of people as they walk through the twelfth-century gates to the medina, the oldest and most labyrinthine part of town. I ask people to pose for me. Not all agree. Children love to pose for the camera. Elders are sometimes flattered and will co-operate. Market vendors and street performers are used to being asked to pose for tourists. A few dollars sometimes allows you to capture very colorful portraits.

I notice an elderly man in front of a ceramics shop in the medina. Feeling awkward about photographing him surreptitiously, I muster enough courage to ask if I can take his picture. He kindly agrees, and afterwards offers me mint tea. Moments like these, when I connect with

people, make a trip memorable. I'm not content just to observe.

A few days later, my journey south of Marrakesh takes me through the snows of the High Atlas Mountains to the sands of the Sahara. I decide to spend a night near the dunes of the Erg Chebbi, at the edge of the Sahara desert. I photograph as the magical light gradually turns the gold-colored dunes to shades of burnt orange. The sun disappears on the horizon. Time to head back — but where is back? Fortunately, I can follow my footprints back to the small hotel, where sand meets soil. The twinkling stars animate the darkest sky. The evening turns magical as locals gather to play drums and sing folk melodies. I quietly hum along, hoping not to be heard. I don't want the night to end.

Anticipation makes for wonderful images. One morning at dawn, after leaving the desert, I observe the town of Tinerhir with its surrounding mountains, waiting to be illuminated by the rising sun. I see a hill and a worn path leading up it. I imagine someone climbing this path and the vista behind him or her. Such a photograph is worth waiting for. Setting up the camera with an 80-200mm zoom lens on the tripod, I position myself to capture a person coming up the hill with the town in the background. The rising sun will make anyone climbing the hill blind to my presence. An elderly man draped in a black cape and holding a leather bag appears at the crest of the hill. I hold my breath as I press the shutter. I know I've captured something memorable. (See page 123.)

I travel through valleys and oases, small towns and remote villages. I aim for variety in my photography and use an array of lenses. A wide-angle lens captures the vastness of the country. I try to create perspective by getting close to an object in the foreground, enlarging it as compared with the background. Using proportion, I endeavor to convey the grandness of towering cliffs over small villages. (See the village of Oumesnat on page 122.) I go for environmental portraits with the wide angle, showing people in the context of where they live. Using a longer lens, I photograph details.

I try to vary the lighting as well. Side lighting is wonderful for emphasizing texture, and it also creates great shadows; back lighting adds contour and drama; silhouettes evoke wonder and mystery. Under the watchful eyes of a resident stork, I photograph the ruins of the kasbah of Telouet. The dark, stormy clouds produce an ominous atmosphere. In contrast, the coastal town of Essaouira offers white and blue houses and the surrounding ramparts perfectly reflected in the Atlantic Ocean.

Elated, near the end of my trip I purchase seven berber carpets in Tafraoute, and in Taroudant a huge urn and matching cabinet, both six feet tall, made of camel bone, wood, and metal. Enchanting Morocco — mysterious, exotic, and visually compelling. It is a feast for the eye, a gift for a photographer.

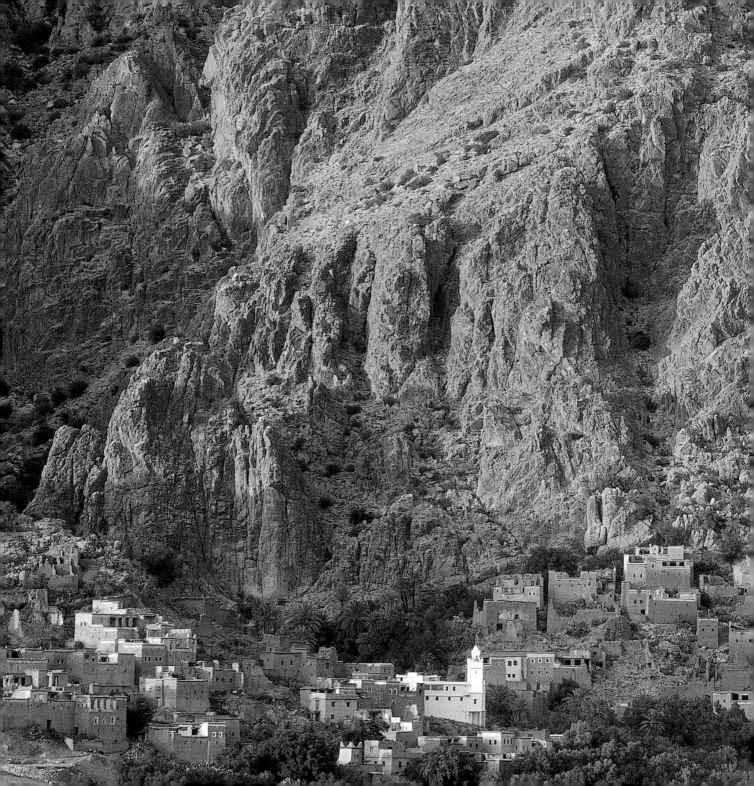

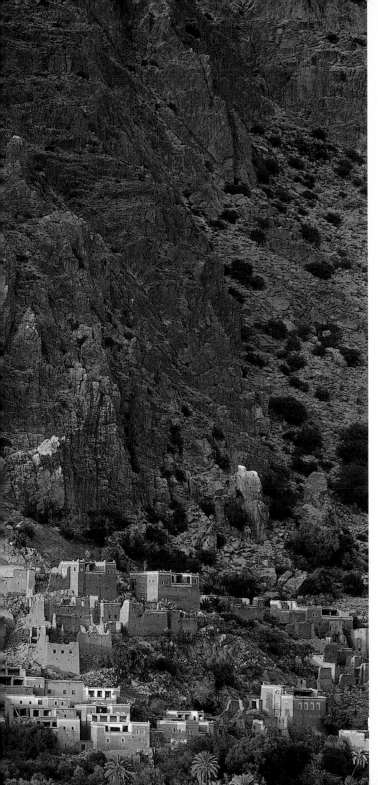

Goat herder in the countryside
between Ouarzazate and Tinerhir

Village of Oumesnat in
the south of Morocco

Man on a bicycle in Marrakesh

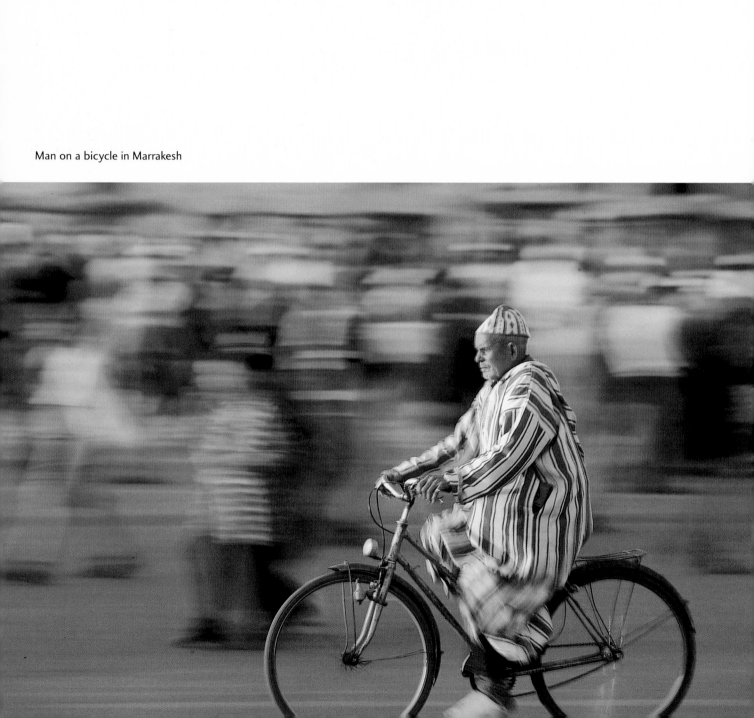

Jardin Majorelle,
Yves Saint Laurent's
garden in Marrakesh

Profile of a young girl in Essaouira

Veiled woman against the
ocher-colored ramparts
of Essaouira

Mexico

Come February or March, I long to escape New Brunswick's harsh winter. Mexico entices me, as much with its colors as with its weather. I'm content exploring the central mining towns – Guanajuato, San Miguel de Allende, or Querétaro – or discovering unspoilt beaches and quaint villages in the Yucatán peninsula. The light is always glorious, the colors vivid and abundant.

On every trip to Mexico I try to discover new areas. Before one of my trips, I read about the beauty of Oaxaca. I restlessly counted the days until my departure.

Oaxaca and the outlying villages are famous for their markets. This means exciting, colorful photography. Each day I travel to different markets in the surrounding area. I leave early so that I can photograph en route and also have time to familiarize myself with the locale before it gets too busy. I take some pictures as people set up their stalls. I wander in the marketplace and look for vibrant colors or faces full of character. Often I find myself leaning against a wall, inconspicuous, waiting for something to happen. After a while the locals ignore me and go about their business. I try to be unobtrusive and capture market life as it unfolds. I buy some fresh fruit for breakfast, and this might be a way to connect with a vendor and get permission to take a portrait. Not speaking the language does not stop me from asking to photograph someone. Hand gestures, pointing at the camera, and a smile go a long way.

The next year I decide to travel to the colonial silver-mining towns, which are inland, a few hours north of Mexico City. I rent a car at the airport and hope to make it to the first town before dusk. An hour later, totally lost in the largest city in the world, I notice a sign for the *periférico*, the highway that surrounds the city, which eventually leads me out. My breathing finally returns to its normal rhythm. I'm on my way to Querétaro.

I enjoy exploring these towns, leisurely photographing the decaying walls that reveal layers of fading paint, small courtyards with pots as vibrant as the flowers they host, bright yellow bell towers stark against a blue sky. Mexicans are bold in their use of color. This excites and inspires me. Armed with Fuji Velvia because of its color saturation, I wander the streets of Querétaro or Zacatecas looking for scenes strong in design and color. I carefully observe the elongated shadows cast by the low sun and try to integrate these into my photos. I'm aware of how the play of primary colors creates strong visual impact. I'm enthralled with my surroundings and ignited by my photography.

The sun is strong and warm. I enter the Iglesia de San Cayetano in Guanajuato. Built when silver was plentiful and Mexico prosperous, the inside is ornate with rich, gold-accented wooden carvings, monuments to a wealthy past. It is cooler in here. Then I continue along the winding road to the center of town. With camera and tripod I walk the many *callejónes*, small cobbled stone streets, and I end up in the central square. It is surrounded by cafés, small hotels, and a beautiful old theater.

As the evening approaches, I put the camera away and observe the park coming to life. The mariachi band appears and many courtships begin. For now I am content simply to watch the night unfold. **AG**

Flowers on a windowsill,
Yucatán peninsula

Painted souvenirs for sale

Tree against a colorful
wall, Querétaro

top: Milk delivery, San Miguel de Allende
facing page: Potted anthurium in a small courtyard, Oaxaca
bottom: Banana lady at a weekly market, Oaxaca

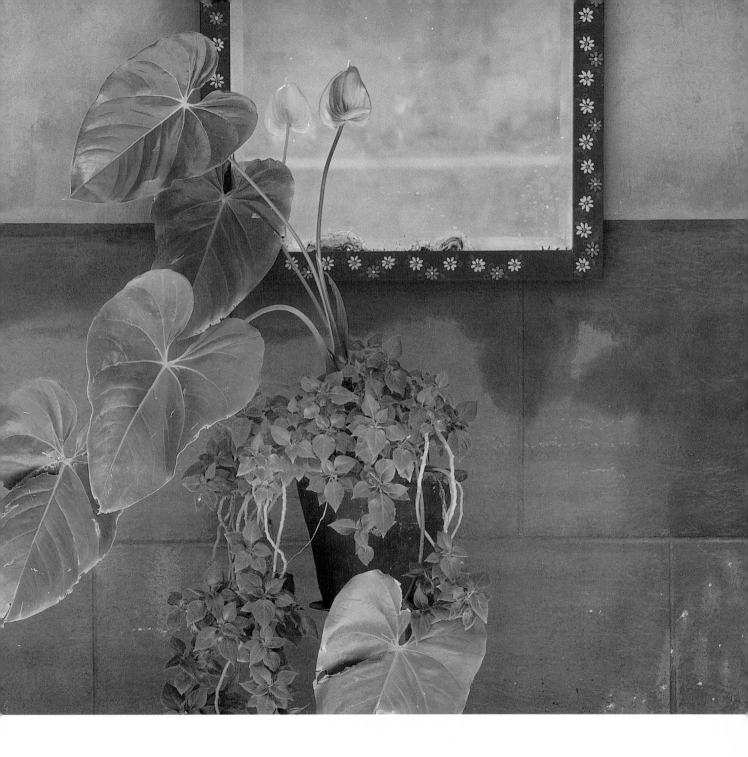

Photographing people

I think a good portrait ought to tell something of the subject's past and suggest something of his future.

BILL BRANDT

In my early twenties, after purchasing my first camera, I started to photograph nature. Autumn foliage, tranquil meadows, and fields of wildflowers were subjects with which I felt at ease. I enjoyed the quiet times alone in the countryside, mist rising at dawn, looking for dew-covered spiders' webs. Photographing natural things suited my "timid" personality. Fortunately, after a few years, I discovered people. For this I have my niece and nephew to thank.

James and Vicky were five and three at the time, and I thought it would be fun to take some photographs of them together. I scouted a small storefront with an old-fashioned Pepsi sign on the door, to give a nostalgic feel to the photographs. I chose black-and-white film, which I thought would add a timelessness to the images. James and Vicky were wearing old jeans and plain shirts. I bought each of them an ice cream cone, and immediately started to photograph. The day was cloudy, and the soft light emanating from the bright clouds was ideal.

Then Vicky, who's a bit rambunctious, dropped her cone. She was upset and it was impossible to calm her down. She jumped all over James, trying to steal his cone. Nothing was going as planned. Finally I asked James to share his ice cream with his little sister. I took a few more shots and, disappointed, decided to call it quits.

After I processed the film in my darkroom and looked at the contact sheet, I was delightfully surprised. The photographs showed kids being kids. Their expressions were both heartfelt and comical. In fact, two photographs from that shoot, *Crème Glacée I* and *II* (see pages 82-83) have become best-selling posters. To this day, when I look at James and Vicky, I am taken back to that old storefront, eighteen years ago. That day I learned my first two lessons in photographing children: let them be themselves, and be prepared for anything to happen.

Getting ready. Be prepared and be organized. People in front of a camera are often uncomfortable to begin with, and they will become impatient if it takes you too long to photograph them. Have your camera loaded and equipped with the right lens. Pre-visualize your por-

trait. Figure out in advance where the light is coming from and decide what background will work best. If you intend to publish the photographs, you will need a model release. Have this form ready and get it signed before you begin to photograph. A witness to the signature on the release is added protection for any photographer. If the subject is a child, have both parents sign the release, if possible.

Approaching people. It's easier to ask to photograph someone you know than it is to ask a stranger. Explain that you want to improve your portrait skills and that you will give your subject a few pictures from the session. I started out photographing children, then graduated to my friends. As my skills improved and I started to receive positive reactions to my portraits, people began asking me to photograph them. I photographed many local fashion shows and public events. As a result, models got to know me and asked me to take some shots for their portfolios. This allowed me to improve both my photography and my people skills.

If you want to photograph strangers, approach them in a sincere and honest manner. As a travel photographer, I routinely photograph people I don't know. On one magazine assignment in Nevis, a small Caribbean island, I noticed an elderly lady standing on the porch of her house. I was struck not only by the character in her face but also by her house, which was painted in gentle shades of pink and blue. I drove by her house three times before I mustered enough courage to stop and ask her if I could take her portrait. Sensing her reluctance, I explained that I was photographing a story on Nevis for a Canadian publication, and was hoping to capture some of the essence of the beautiful island and its people. Still

unsure, she asked me to return the next day so she would have time to think about it. The next morning, she was in her Sunday best. "I have a question before agreeing," she said. "Are you Catholic?" My answer must have satisfied her, because she allowed me to take her portrait.

Film selection. In portraiture, film is a matter of choice, and on occasion you may decide to use black-and-white. With the traditional black-and-white films it is possible to proof the negatives on a contact sheet and then select the best images for enlargement. Films in the speed range of 100 to 400 offer good sharpness and contrast. You can get wonderful results with the recently introduced black-and-white films that can be processed in c-41 chemicals: Kodak t400 cn, Ilford xp2, and Konica vx Monochrome. These are discussed in more detail in the chapter "Choosing a film to create a mood."

You may choose to use color negative film so you can give a set of prints to the subject of your photographs. You will get excellent results with films in the speed range between 100 and 400 asa, the latter having a bit more grain but offering more flexibility by allowing a faster shutter speed, especially useful for candid portraiture. If you use slides, films such as Fuji's Sensia or Astia, and Kodak's e100s, all having a speed of 100, offer a natural color palette suitable for photographing people.

I always determine well in advance which film I'm going to use when I take someone's portrait. I may choose a film to help me create a particular atmosphere, or the setting might influence my film choice. So might the lighting situation. With experience, film selection becomes easier.

Lighting. Light, whether natural or artificial, is essential to photography. Because I photograph most of my portraits outdoors, I've had to learn the qualities of natural light at different times of day and under a variety of weather conditions. A sunny day provides beautiful light early in the morning, when the sun is low, and later in the day, about an hour before the sun sets. At these times your subject can face the sun, and the light will then cast a warm hue that is very appealing in portraits. When the sun is higher and its light intensifies, it is difficult not to squint at the facing sun. In that case position the subject so the sun is at an angle, creating a slight shadow from the nose onto the cheek. You can use a reflector to bounce some light onto the person's face, reducing contrast and adding catch light – the reflected bright spot in your subject's eyes. Collapsible reflectors come in different sizes and with variable surfaces: silver, white, or gold, reflecting strong, soft, or warm light. Alternatively, in strong, direct sunlight you can photograph in profile, so your subject does not look into the sun.

You should also consider using back lighting. With the sun behind the person, you can use a reflector to illuminate the face. This creates a gentle aura and provides good background separation; because of the contouring of the light, the subject stands out against the background. In this situation be especially careful of lens flare. Use a lens shade or your hand to prevent the sun's rays from shining on the lens. Because backlighted situations are trickier to meter, this is a good time to bracket your exposures: photograph on meter and then take extra shots, above and below the meter reading. In this instance I usually take a meter reading right on the face and expose accordingly.

On days when it is so bright that squinting is inevitable, move into a shaded area where there is enough reflected light to illuminate your subject – against a light wall perhaps, or near a bright street. Make sure there is a catch light in the person's eyes; this makes portraits come to life. The photograph of the four schoolchildren in Jamaica (page 141) was shot in the late morning. As the direct sunlight was too intense, I moved the children into the shade, where there was plenty of reflected light.

Open shade or bright, cloudy days provide beautiful illumination for portraits. This light, soft and diffused, is very gentle on the human face. In this situation I normally use a reflector as well, to add that extra glint to the person's eyes. One disadvantage in shaded areas is that the light sometimes has a slight blue cast reflected from the blue sky, but you can correct this by using a warming filter (81A). Avoid photographing under heavy foliage because the film could pick up a faint green tint.

Indoors, you can replicate natural light with an on-camera flash – either pop-up or attached – or two to four studio lights. Moving the light source rather than the subject allows the photographer greater flexibility and control. However, the light of an on-camera flash is direct and harsh, and therefore not the most flattering. With a studio lighting system you are able to position your lights more effectively. A flash meter will allow you to measure the amount of light the flash is emitting.

A variety of tools will help you simulate different lighting conditions. An umbrella or softbox will soften the harsh light that emanates from a flash head. Scavullo, the great beauty and fashion photographer, uses one flash head, with an umbrella above and slightly to one side of the people he photographs. This type of lighting is often referred to as "beauty" light. Additional flash

heads will help with lighting the hair and background. These will have to be balanced with the main light.

If you intend to purchase a lighting system, go to a reputable photographic store that has knowledgeable salespeople who will be able to advise you according to your needs and budget. I own a four-head flash system that meets my needs as a freelance travel photographer. It allows me to light portraits as well as an average-sized room interior.

Other forms of artificial light will need to be filtered for portraits. Tungsten light, found in most homes, is very warm and can be moderated with a blue filter. Fluorescent light, used in stores, offices, and some rooms in homes, has a green hue and needs to be filtered (FLD magenta filter) if you're shooting color film.

Making portraits, and posing techniques.

To quote the late photographer Robert Mapplethorpe: "When a picture is successful, it goes beyond the sitter – the subject no longer matters, really."

What to include in a portrait will be determined by what you want to communicate. A travel portrait may include something in the background to add a sense of place. If you want to concentrate on a person's character and facial features, exclude background. Working with a zoom lens, you can do both without spending a lot of time changing lenses and repositioning yourself. A medium-range lens (100mm to 200mm) allows enough distance between you that your subject will not be intimidated. By using shallow depth of field, the range of this lens permits you to blur the background, putting the emphasis on the subject. This range has reduced distortion compared with shorter focal length lenses, which would enlarge features closer to the camera. It also does not have the exaggerated compression found with a longer focal length lens, which can make the face appear flat.

To help the subject feel at ease, take your portraits in a setting devoid of distractions and onlookers. Make conversation as you set up a shot or change a roll of film; this will also help the subject to relax. Long pauses may make your subject ill at ease.

When photographing headshots, instead of posing the person head-on, have the model angled to the camera, with a slight tilt of the head. This creates nice lines and conveys a more relaxed feeling. The eyes should have a catch light in them. Portrait purists do not like more than one catch light, but if I'm photographing outside using natural light, I'm pleased with however many glints appear in the eyes, as this creates a sense of aliveness. If the subject wears glasses, avoid reflections by raising the light or tilting the head slightly downwards.

In a portrait, the nose should be contained inside the cheekbone. If your model is at an angle, it is distracting if the nose appears to protrude, cutting the cheek contour. A long chin or nose will appear shorter if you lower your camera position. To minimize a double chin, use a higher camera position and ask your model to lean the head slightly forward. A profile can be quite dramatic and also conceal flaws like uneven eyes.

Ask people to lick their lips lightly. Make sure that teeth are not in shadow, and don't show them if they're not attractive. In the studio, face powder will eliminate glare on the skin. Light on a person's hair is desirable. Always watch for squinting and frowning.

Posing. The pose is critical to the success of any portrait, and the objective is to make the subject look

comfortable and relaxed. The photographer has to make sure that the pose looks natural, and I usually demonstrate the pose I want. If your subject is seated, make sure the position is comfortable. Tell the subject to cross legs or shift weight if necessary. Observe these movements and you will see that some positions are more flattering than others. Sitting straight looks better than a slouched position.

If your subject is standing, again choose a pose that makes the person look comfortable and at ease. Often people don't know what to do with their hands. Crossing arms, putting hands in pockets, or leaning against a wall with hands behind the back are possible solutions. Ask the model to turn slightly to the camera, both ways, and observe carefully; one side is often more photogenic.

Photographing women. It is very exciting to try your hand at fashion photography. As a young photographer I dreamed of having the chance to photograph professional models like Iman or Paulina. So I found local models who needed pictures for their portfolios. We worked together with a make-up artist and hair stylist, trying to replicate the latest ads in the pages of *Vogue*. I learned a lot on these shoots, especially how to choose the right film to capture a mood. I used black-and-white film, which I processed and printed myself. As I provided prints for the models and stylists, this kept my costs down.

Here are a few tips that may help you:

Keep the hair simple. Keep the make-up natural. Don't use "trendy" shades that will date the look of a photograph. The same goes for clothes. Classic wear never goes out of style. Make sure the model looks and feels at ease with what she's wearing. Avoid revealing clothes or bathing suits until you and the model feel comfortable working together. If either of you is inexperienced, working outdoors will be more relaxing than posing in the confines of a studio.

The eyes are the gateway to the soul. A direct gaze into the camera will produce a more intimate portrait. Some of the most memorable portraits are ones that make you feel the person is looking straight at you. Diffused light is flattering, and a soft-focus filter will soften the image and conceal wrinkles.

Do not over-direct the model, and make conversation as the shoot progresses. Let your model know how well she's doing. Taking the photographs should be incidental. As you develop a rapport with your model, the photographs become more natural and successful.

Photographing men. Portraits of men will often emphasize the lines of character rather than conceal them. In a studio, using a main light without diffusion will sculpt facial features and emphasize bone structure and lines. Then add a light to illuminate the hair, and another one aimed at the background, to separate the subject from the background. On occasion I do use a softbox – a large rectangular attachment over a flash head, which replicates window light – to light one side of the face, letting the other side fall into shadow. This will help outline a man's jaw. Depending on the effect I want to achieve, I may lighten the shadow side with a reflector.

The outdoor portrait permits more spontaneity and action. You can photograph men working – firemen, construction workers, farmers in their work clothes – or men at play – fishing, jogging, or perhaps playing baseball.

Photographing teenagers. It is easy for photographers to be intimidated by soon-to-be adults. To capture a natural look, try photographing teenagers in action: dancing, playing a sport, riding a bike, kayaking. If they have attitude, try to capture it. Teens may want to be photographed wearing favorite clothes, jeans, a leather jacket, or sunglasses. If they are of driving age, it could be a "cool" shot to photograph them leaning against a car or motorcycle, a proud look on their faces. Teenage girls will surely want to look older and will wear makeup and trendy clothes. Guys like to look confident. Go along with these preferences. If the teen has acne, it won't be as obvious if you use black-and-white film. A soft-focus filter is also useful to conceal blemishes on the skin. Opt to take pictures from farther away rather than photographing just the head and shoulders. Make the photo session a joint project.

Photographing children. I started the transition from photographing nature to people by taking pictures of children. Kids between the ages of three and seven are good subjects: they are playful and not too self-conscious in front of the camera. Because children are active and move around so much, I recommend you use a medium-speed film – ISO 200 or 400 – that will allow you to photograph action shots by using a faster shutter speed. Print film is ideal because exposure is not as critical as it is with slide film, and the parents will appreciate receiving some prints once the film is processed. Work with a tripod, but don't be constrained by it.

Choose props that are fun and will excite the child: a pet, perhaps, or a new toy. The more the photo session feels like play, the longer you'll have to make your photographs. If all else fails, try a bribe. Sometimes the promise of an ice cream cone is all it takes for a child to be more co-operative.

Shoot from different angles. If you photograph standing up, aiming your camera down at the child, you will create a sense of vulnerability. If you get down low and shoot upwards, the photograph will have a totally different feel. Try panning shots as the child runs. Go for spontaneous moments as well as posed pictures. Be playful. Act silly. Make the kid laugh. Let the child see you as a friend rather than an adult doing a job.

On a shoot with my friend's four-year-old son, Richard, I gathered a variety of props – umbrella, strawberries, garden vegetables – with preconceived images in mind. Halfway through the photo session Richard grabbed two bare branches, held them on top of his head, and pretended to be a moose. That was "the shot," simple and spontaneous. It instantly brought back all kinds of childhood memories.

If you're photographing indoors and decide to use available natural light, choose the brightest room and, if possible, photograph near a window. You could get the child to pose for you and also take pictures of the little one coloring, looking at a book, even sleeping. I often photograph children looking out a window, trying to capture different expressions that convey different moods. Sometimes I'll slip outside and take a few shots through the window as well.

Photographing babies. Photographing a baby can be quite an undertaking. To get the most out of a photo session, allow yourself plenty of time. Babies do many things in the space of a few hours, and you should aim to capture as much as you can on film: eating, a face covered with food, laughing and crying, sleeping. Some

stages in a baby's life are more difficult to photograph than others. Because they are never still, babies at the crawling stage can have you pulling your hair out. In this case it might be easier to photograph the toddler in a crib or playpen. I often use a plastic tub filled with water and lots of bubbles. I ask the parent to bathe the baby, and then I photograph as the baby splashes away. An infant draped in a thick towel also makes for a charming photo.

Because it can be difficult to hold an infant's attention, try not to have people around except for the parents. One parent could stand behind you to draw the infant's gaze, so it seems as if the infant is looking into the camera. I often make silly noises to get babies to look at me. It may also help to have a new toy or something that intrigues the infant, such as a music box or any colorful object. Parents, needless to say, have a special bond with their baby, so do not overlook the possibility of photographing them together. If nothing seems to work, you may have to resort to photographing the baby asleep, taking close-ups of tiny hands and feet as well as the peacefulness of the sleeping infant, tenderly covered with a soft blanket.

Recently, I photographed a baby for a friend and neighbor. Jaden was born three months premature, so at three months he was like a newborn. His mother, Michelle, wanted a photograph. Because their house has small rooms, and because I didn't want to be crowded with lights and softboxes, I decided to photograph with natural light near a window. I wanted to concentrate on the baby and his expressions rather than be concerned with flash readings and recycling times. I used Kodak T400 CN. At a speed of 400, with my camera on the tripod, I had enough light to capture Jaden's delicate features. Where color film might accentuate blemishes on a baby's skin, black-and-white tends to camouflage them. Also, Michelle loves black-and-white photographs. I spent an hour photographing this tiny baby. I was rewarded with animated bursts of joy, as well as sad expressions as he teetered on the brink of crying. I took pictures of the baby cradled in his father's rugged hands. As Jaden got tired, I made a final photo of him asleep on his father's shoulder (see page 56). AG

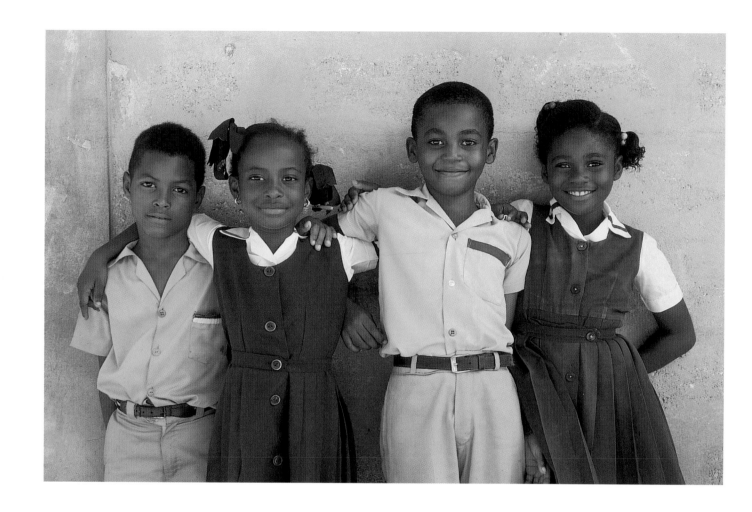

This photograph was taken in 1989 at an elementary school in Jamaica. It does not look dated thanks to the students' uniforms. I had to move the children into the shade as the sun was extremely bright, making them squint, and the light very contrasty. There was sufficient light reflected from the ground to allow me to take this portrait.

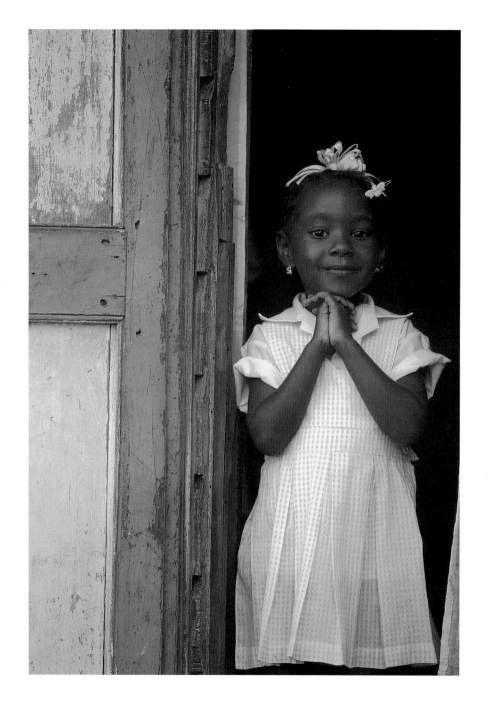

A magazine assignment in the Caribbean took me to the small island of Nevis. Driving in the countryside, I noticed this little girl in her uniform, about to leave for school. I stopped and asked the mother if I could photograph her daughter, whose name was Shenelka. They both agreed, and I took a few shots of this sweet child standing in the doorway. In her shyness, she clasped her hands together and brought them under her chin, a gesture I found very endearing. Shenelka appeared in the magazine, both inside and on the cover.

In Barbados, driving back to my hotel after photographing a glorious sunrise, I noticed this elderly man with his cane, sitting by the side of the road. I kept driving, but his image seemed imprinted on my mind. I turned around and went back.

After a bit of conversation I asked James if I could take his photograph. His reply was: "How much is this going to cost me?"

When Agfa Scala film first appeared, I took a few rolls with me on a trip to Mexico to try it out. I photographed a variety of subjects and was especially impressed with the portraits. By hand gestures and pointing to the camera I conveyed to this man that I wanted to take his picture. He nodded in agreement and I proceeded to take a few shots, concentrating on his face, on capturing his intense gaze.

This photograph of my friend Christine is from way back, when I was making fashion and beauty shots in my hometown. With friends I would plan a photo shoot, and everyone would donate their services for a few photographs. I kept expenses to a bare minimum and reaped enormous benefits. I learned about light, photography, and people, and made a number of close friends. This image was taken in my mother's living room, using a softbox as the main light and a reflector. The clothes and hat were borrowed, and I was helped by Myriam, who did the make-up, and Kerry, who styled the photograph.

Tinerhir, Morocco. For a few dirhams – one or two dollars – this man and his camel pose for tourists. I was more interested in taking his portrait than photographing him with the camel. Although I did take some photos that included the animal, it is this close-up I find more interesting. The early evening light is soft and warm on his face.

THE SUBJECTIVE IMAGE

I planned to photograph Vince in the late afternoon so we could make use of the magical light at that time of day. We decided to take some shots in the pool to highlight Vince's fit body and also to show his tattoo. The sun was still too strong, so I asked him to close his eyes to avoid squinting.

These two women were chatting on a porch and I just wanted to capture that bit of intimacy, two old friends telling stories. I stopped and asked if I could photograph them. They agreed, so I asked them to keep talking to each other. There was enough reflected light on the porch to allow me to hand-hold the camera, with a 28mm wide-angle lens at about $^1/_{30}$ second, using Fuji Velvia film.

Because I approached this lady in a sincere and honest manner, she allowed me to take her portrait. I took time to tell her about myself and my intentions, and to ask questions about her. When I returned the next morning, her hair was pinned back and she was wearing a beautiful dress.

THE CRAFT AND ART OF PHOTOGRAPHY

. . . to stop rushing around, to sit quietly on the grass, to switch off the world and come back to Earth, to allow the eye to see a willow, a bush, a cloud, a leaf, is an "unforgettable experience."

FREDERICK FRANCK, "THE ZEN OF SEEING"

The craft and art of photography

It is harder to see than it is to express.

ROBERT HENRI, "THE ART SPIRIT"

In photography, as in every other artistic medium, the relationship between craft and art is always an open question, a good one for discussion and reflection.

The majority of sculptors, painters, singers, writers, dancers, and photographers are not artists, and they have no pretensions to being artists. They sing because they love music and can carry a tune well; they paint because they love color or because the personal re-creation of a scene gives them pleasure; they carve because they enjoy "whittling," or making things out of wood or clay. They photograph because it is a good way to remember their children at various stages of life, or because they want to relive moments from their trips. These are all worthwhile activities, and many, but not all, of the results will be very good. A great deal will depend on how well people know the tools and various techniques of their particular medium, and how interested they are in devoting the time and energy required to produce results of fine quality.

Commercial photographers — people who make their living by shooting for newspapers, stock photog-raphy libraries, or commercial clients such as fashion houses, food corporations, and local businesses, or those who operate studios and shoot everything from baby pictures to high school graduation classes to por-traits of families and other groups — must be good craftspersons. Either that or they're out of business, because for the most part clients expect a high level of quality. Commercial photographers always endeavor to meet the needs and desires of their clients, but with receptive clients who do not have highly specific requirements, they may seek to lead visually. Experi-mentation with, and interpretation of, an assignment can give the photographer a heightened sense of satis-faction, especially when the client is excited by the results. It's not all that different for amateurs, except that they have something of an advantage over people who photograph solely to make a living. Amateurs can devote their energy entirely to those things they care about, learning the tools and the ways to capture the images that are meaningful to them with sensitivity and caring. For both amateurs and professionals, proficiency

in the craft should be a matter of genuine personal satisfaction.

For the most part, however, excellence in craft does not constitute art. More than any other factor, what makes an artist an artist is that he or she works with and from his or her spiritual center. For me, art is the message – feelings, passions, caring that arise from the unconscious. Craft is the means of delivery. Craft is the left brain at work; art is the right brain using the work of the left.

This fundamental distinction between craft and art in photography becomes especially apparent when the techniques involved in rendering something in a particular way are difficult or complicated. The techniques are emotional barriers until you conquer them; then they are liberators. Perhaps using multiple exposures as an impressionistic technique is a good case in point. As I mentioned in the first chapter, I exposed dozens and dozens of rolls of film in order to learn how to produce different effects. Only by doing that did I gain sufficient familiarity with the techniques to be able to apply one to this subject and another to that almost instinctively – in response to my feelings about the subject matter. Only then did the ineffable experience of art become possible.

I believe that being an artist is not a permanent state. Rather, it seems to me that a person has relatively long or short periods of artistic endeavor and achievement, and that every artist is otherwise, and necessarily, a craftsperson. I often use the example of a pianist who moves an audience deeply with her performance of a certain concerto. Many may express their feeling that she is a great artist. Yet the next afternoon these same people might find her at home practicing scales on her grand piano – in other words, being a craftsperson. Her repeated practice of fundamental piano work and of the concerto itself – that is, her continual attention to her craft – makes it possible for her to stop "thinking" about craft when she's playing for others and to move freely into the realm of spirit. The music flows through her and from her, not merely in a technical sense but in an emotional sense. And the audience also responds with feeling. That is the pianist's gift, as an artist, to them. But she was a craftsperson yesterday, and she will become one again tomorrow. It's no different with photography and photographers.

For André and me, writing and speaking about personal approaches to photography means that we believe in every individual's capacity for meaningful self-expression. We also believe it's important. Our hope is that we have encouraged you to pursue the crafts of photography and of seeing for your own sake – so you can receive and send messages from where you live, your interior self. **FP**

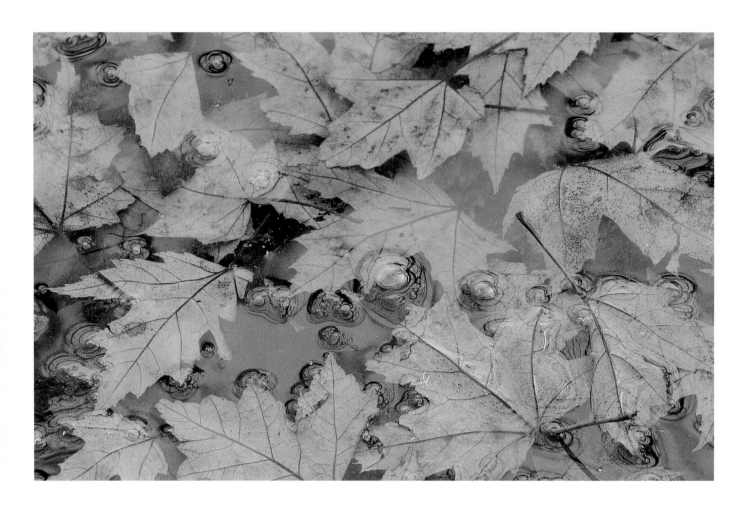

page 150, opposite, and above: Freeman and I decided to put some of our favorite photographs in this concluding chapter. I was going to include images of the Namibian desert and trees of the New Zealand rain forest. After reading Freeman's words, however, I picked three recent photographs taken in New Brunswick, a few kilometers from home. I can still feel the mornings when I took these images: cloudy, damp autumn days, not quite winter, with no vibrant colors left. There is a delicacy in the photographs – the subtle colors, the harmony of the leaves with the water, not quite frozen, the blades of grass in the ice, holding on to enough chlorophyll to sustain a green hue. I feel a quietness looking at these, a sense of coolness in the air. A change of season is upon us.

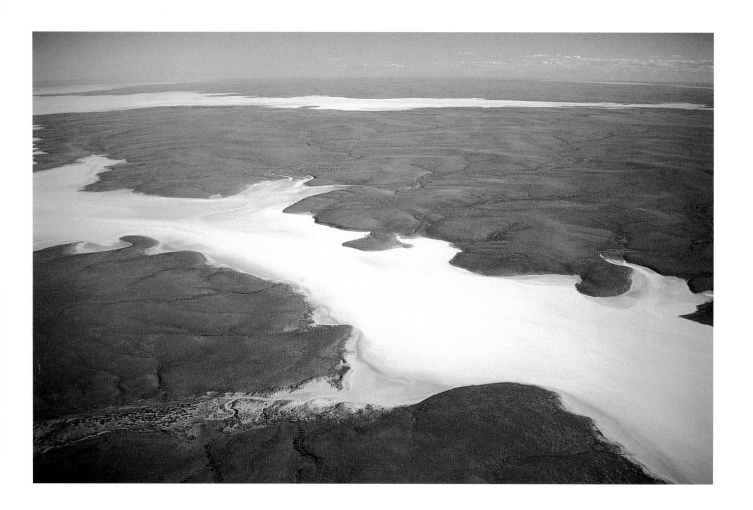

Both of these images, aerial photographs of Australian deserts, are documentary on the one hand but highly subjective on the other. Deserts appeal to me so deeply that I am willing to believe that, in a previous aggregation of energy, I had a profound connection with them. One friend of mine believes that when we feel such a profound, inexplicable reaction to a specific location, we are really tapping into past life memory – soul memory. She and I find it completely reasonable to think of Earth as a gigantic memory bank.

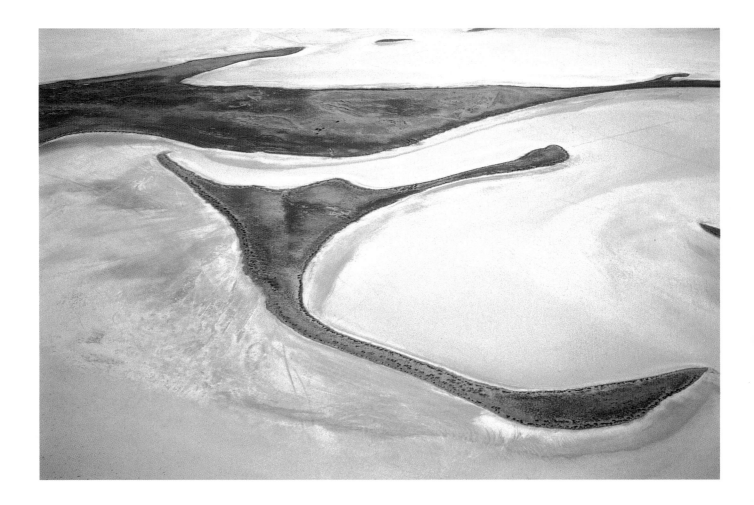

Another friend found this image very feminine and the facing one very masculine. While her comments were not provoked by me, it's obvious that her feelings were. I chose what to photograph and where to place it in the picture space. Both of us brought our subjective reactions to the situations.

Subjectivity sometimes pits the viewer against the creator of an image. The photographer may be so at ease with the craft that he or she finds it easily facilitates the expression of personal feelings. The viewer, on the other hand, may interpret from very different life experiences.

This is both a physical and a visual impression, one that I could not resist including in this book. Although the imprints resemble footprints, they are not. When you examine the shadows carefully, you may realize what happened here. But whether you do or not, I hope you will permit yourself a long excursion into the huge world of photo impressionism, a sphere where emotional reality is more important than physical fact.

About the authors

André Gallant

André Gallant specializes in travel photography and works throughout the Caribbean, Europe, North and South America, and Africa. In 1996 he joined Freeman Patterson as a teaching partner in the visual design workshops at Shamper's Bluff. His work has been seen in *Photo Life*, *Canadian In Flight*, *Canadian Living*, *Canadian Geographic*, *Elm Street*, *Gardening Life*, and *enRoute*. He was the photographer for the illustrated books *Winter*, *The Great Lakes*, and *Seacoasts*, all written by Pierre Berton. He has received several National Magazine awards for his work for *Destinations* and *enRoute*. He lectures and conducts workshops in New Zealand and Israel, and does presentations in the United States and Canada.

Freeman Patterson

Freeman Patterson lives at Shamper's Bluff, New Brunswick, near his childhood home. He has a bachelor's degree in philosophy from Acadia and a master's degree in divinity from Columbia University, and studied photography and visual design privately with Dr. Helen Manzer in New York. He began to work in photography in 1965, and numerous assignments for the Still Photography Division of the National Film Board of Canada followed.

In 1973 Freeman established a workshop of photography and visual design in New Brunswick, and in 1984 he co-founded the Namaqualand Photographic Workshops in southern Africa. He has given numerous workshops in the United States, Israel, New Zealand and Australia, and England. He has published ten books and written for various magazines and for CBC radio. He has been featured on CBC television's *Man Alive*, *Sunday Arts and Entertainment*, and *Adrienne Clarkson Presents*.

Freeman was awarded the Gold Medal for Photographic Excellence from the National Film Board of Canada in 1967, the Hon EFIAP (the highest award) of the Fédération Internationale de l'Art Photographique (Berne, Switzerland) in 1975, doctorates from the University of New Brunswick and Acadia University, the gold medal for distinguished contribution to photography from Canada's National Association for Photographic Art in 1984, the Photography Society of America's Progress Medal (the society's highest award) in 1990, and, in 2001, the Lifetime Achievement Award from the North American Nature Photography Association. He was appointed to the Order of Canada in 1985.